YOSEMITE VALLEY

The great rocks of Yosemite are the most compelling

formation of their kind. We should not casually pass them by

for they are the very heart of the earth speaking to us.

You cannot say that you have known them
 until you have seen them in sun and shade,

watched the cloud shadows flow across them,
 or the clouds congeal around them.

You must know them in the severity of dawn, in blazing noon,
 and in the nostalgic afterglow of dusk.

Cover: HALF DOME, AZALEAS

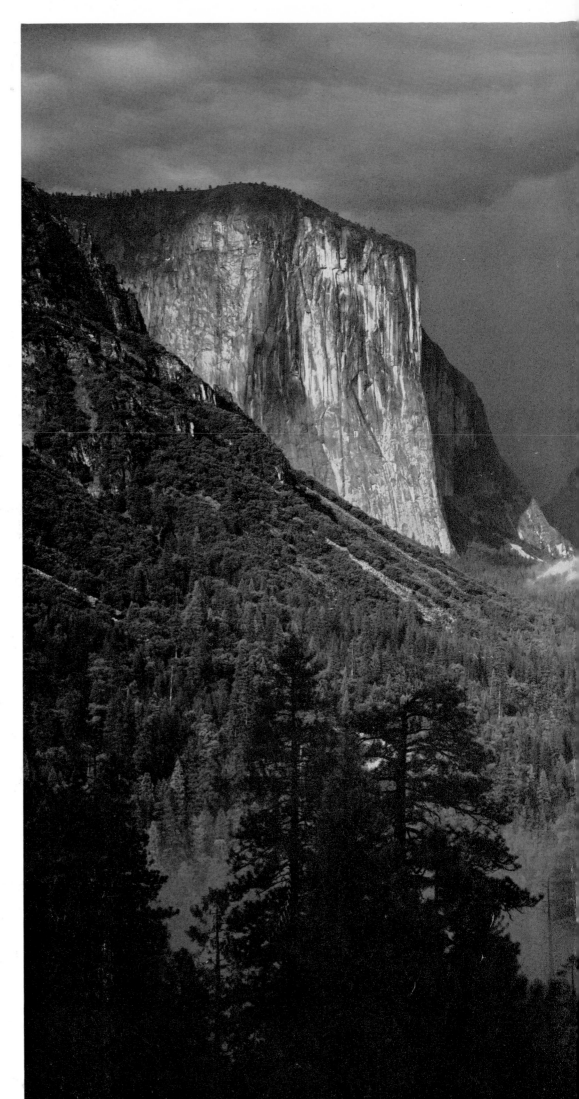

1. YOSEMITE VALLEY, THUNDERSTORM

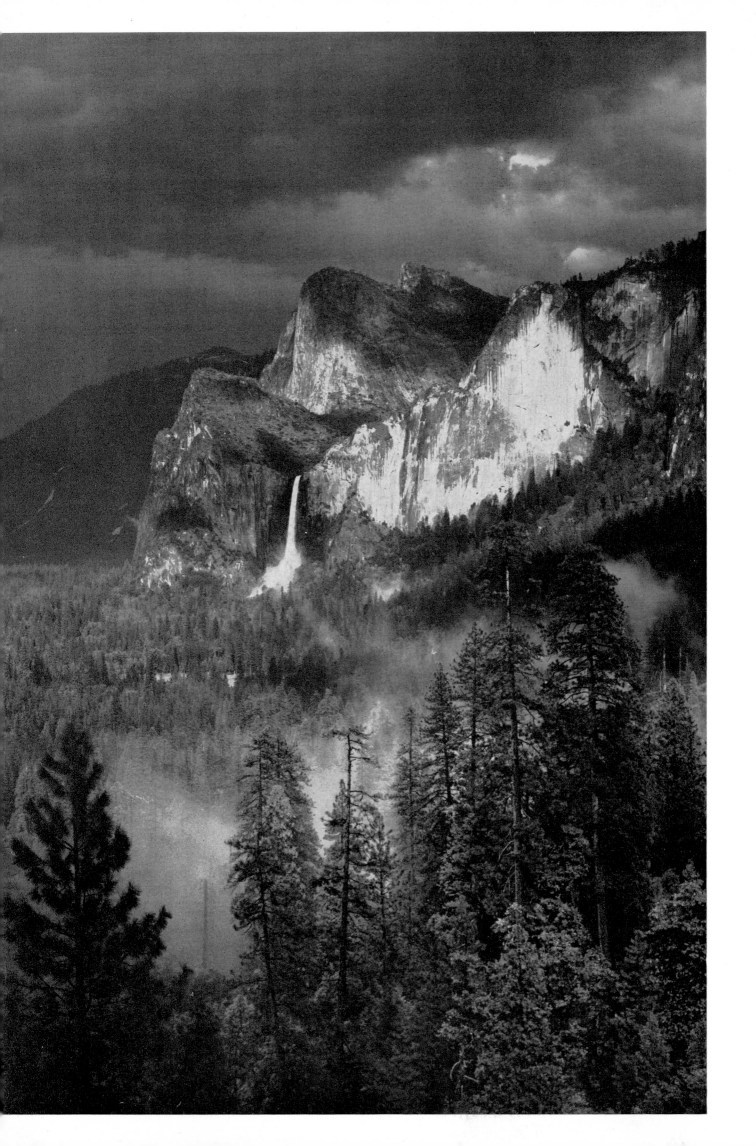

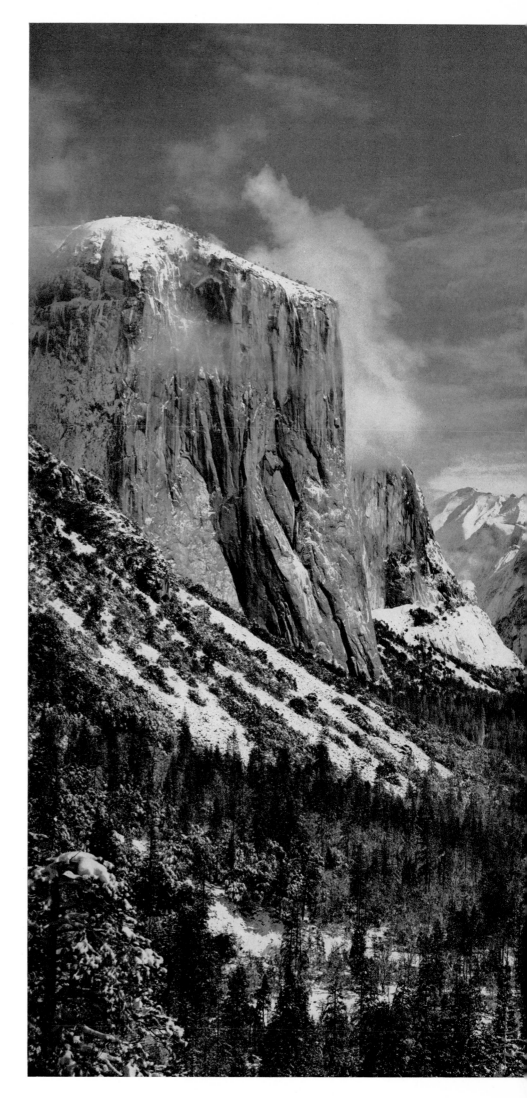

2. *YOSEMITE VALLEY, WINTER MORNING*

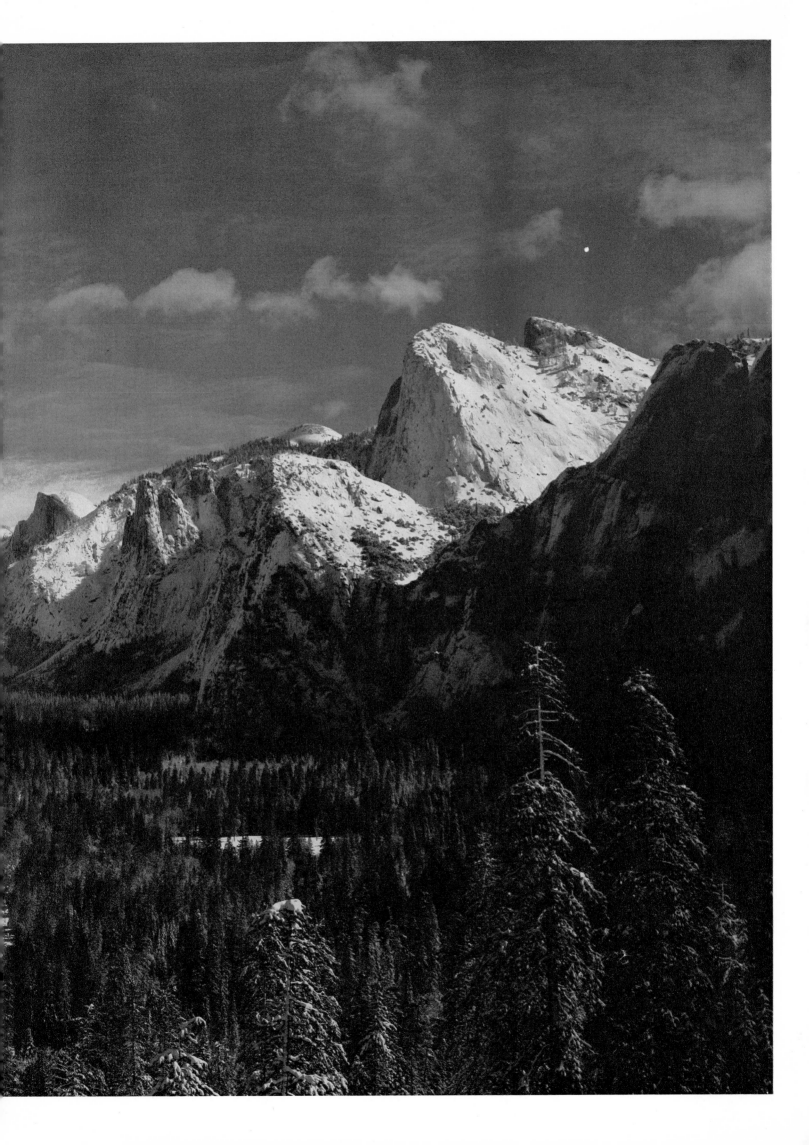

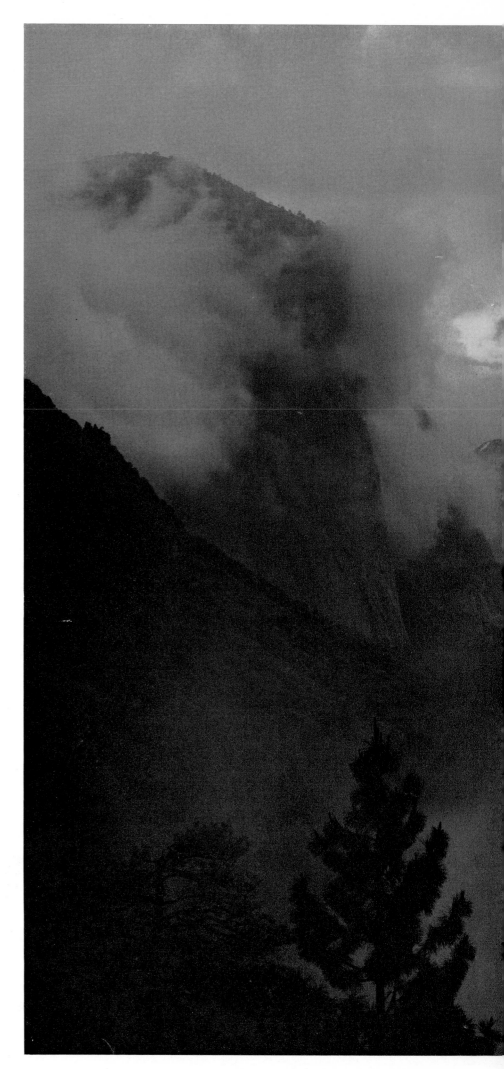

In storm there are constant
 interplays of light and shadow,

moods of clarity and obscurity,

vast complexities and ethereal
 simplicities.

3. *YOSEMITE VALLEY, RAIN AND MIST*

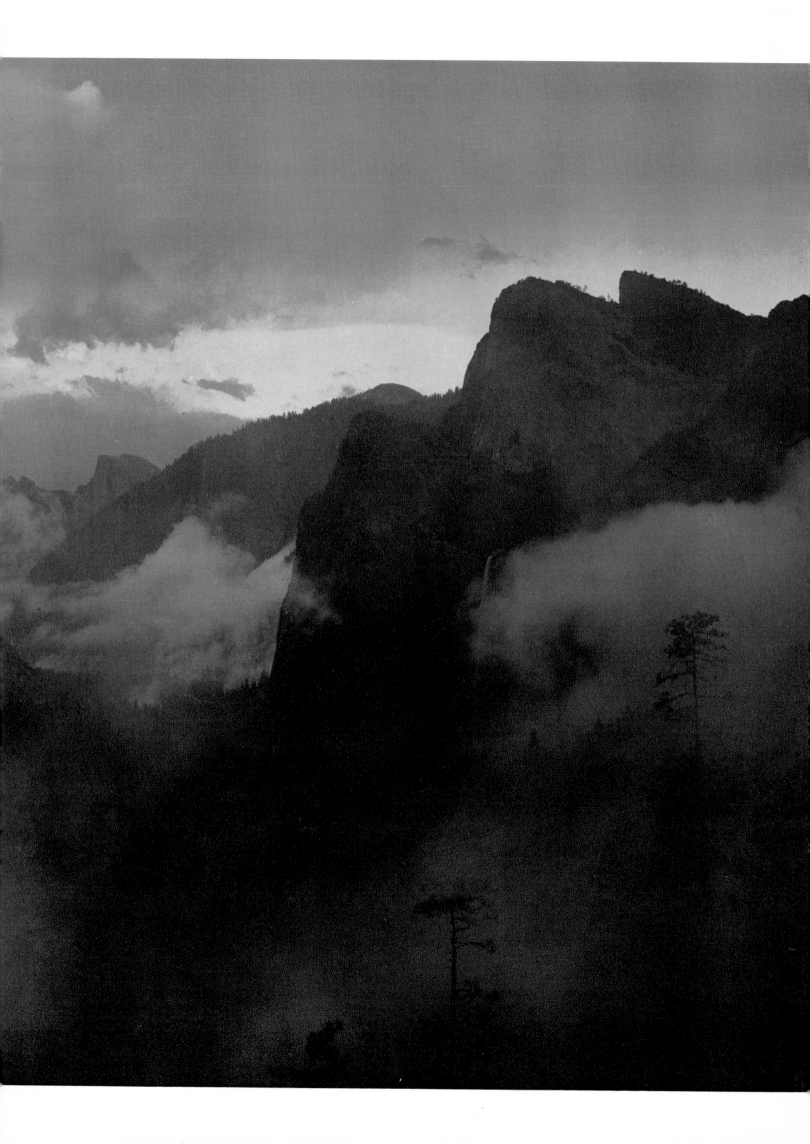

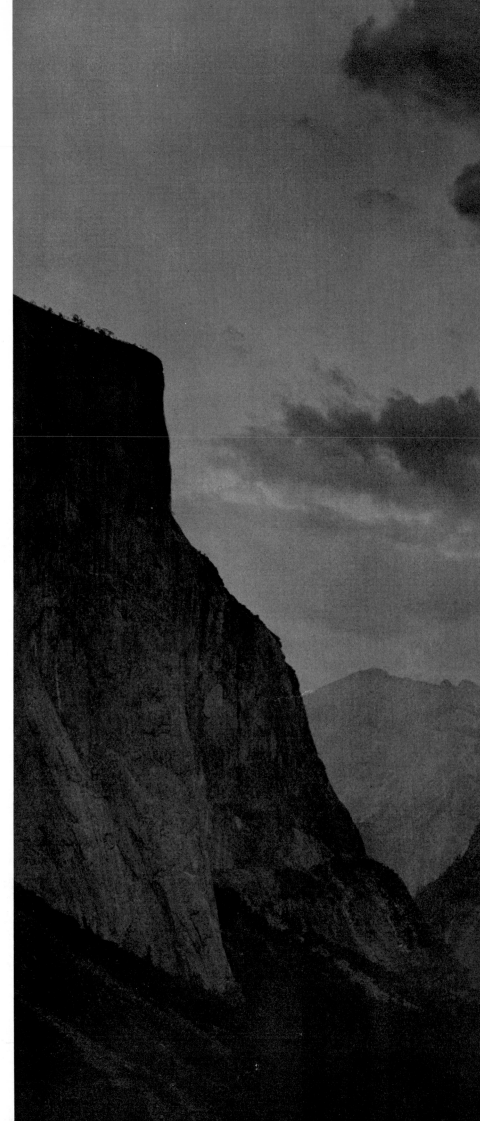

Firm and everlasting as they
 appear, by day, by moonlight

the rocks become vast
 as the earth itself

and of glowing volatile
 substance and form.

4. YOSEMITE VALLEY, MOONRISE

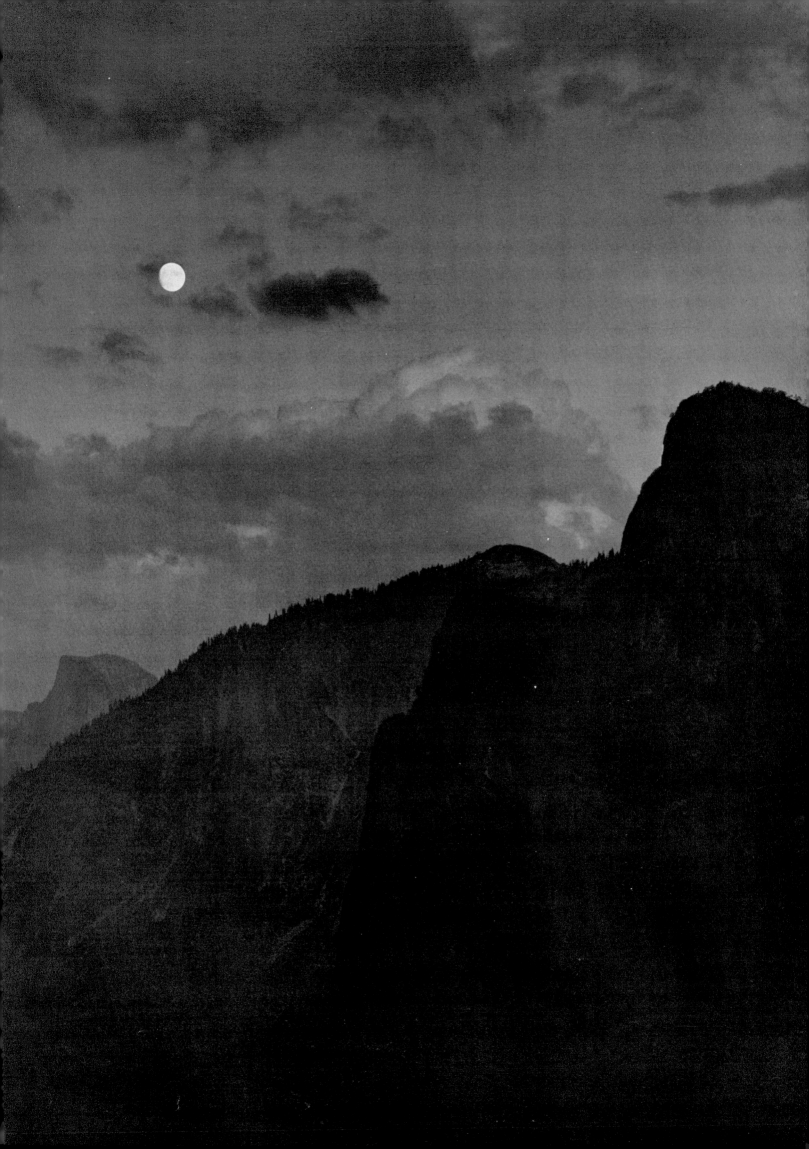

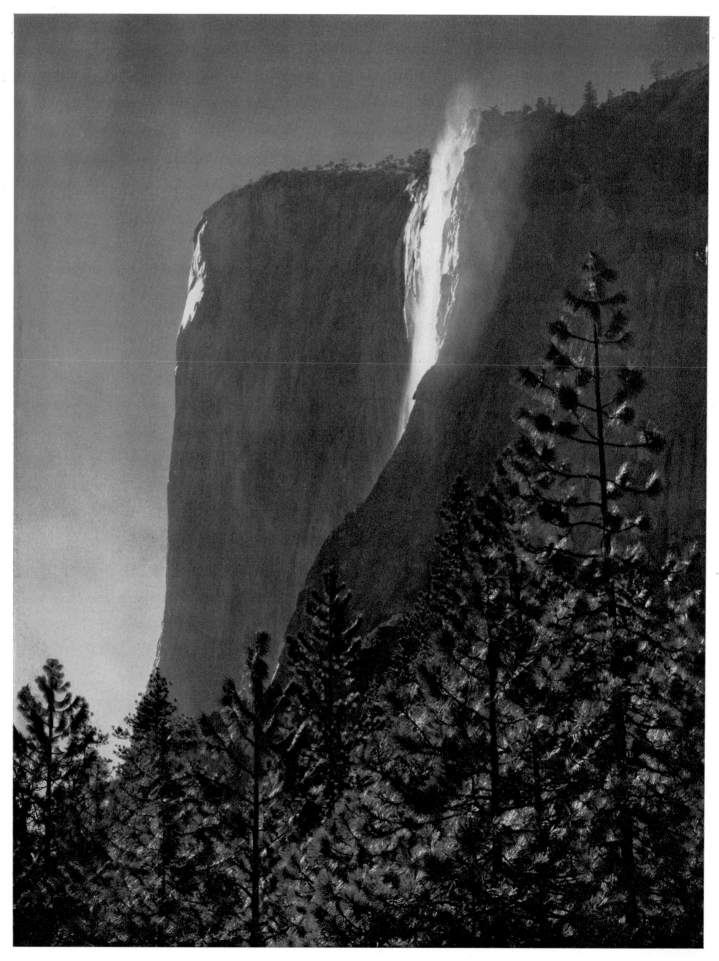

5. EL CAPITAN FALL, SPRING

YOSEMITE VALLEY

BY

ANSEL ADAMS

EDITED BY

NANCY NEWHALL

5 ASSOCIATES · REDWOOD CITY · 1967

SECOND PRINTING · 1963
THIRD PRINTING · 1967

TO CEDRIC WRIGHT, companion on the trails and of many journeys of the spirit, who has so beautifully affirmed the meaning of the high mountains.

CONTENTS

Foreword, Nancy Newhall

ACKNOWLEDGMENTS: We are indebted to many friends and associates for assistance in the production of this publication. We cannot mention them all here, but our especial thanks are due to Douglass Hubbard of the Yosemite Museum, Francis P. Farquhar, Virginia Adams, Roland Meyer, and to the fine craftsmen of the Walter J. Mann Company (engravings) and the H. S. Crocker Company (printing).

FOREWORD

Sculptured in crystalline granite by ancient glaciers that are now bright streams, Yosemite Valley is one of the great gestures of the earth. It lies deep in the heart of the Sierra Nevada, yet millions come to it on pilgrimage from across the world. There is not only beauty here but magic, and an exaltation, and a sense of continuous revelation.

Its seasons follow each other like the movements of a symphony. In spring, it is full of soaring lights and singing waters. In summer, the sun's deep blaze on slope and summit darkens only with the passing of majestic thunderstorms. In autumn, the low sun from behind dome or spire turns the forest into sudden gold, and through the crisp stillness a rustle comes sharp to the listening ear. In winter, in the hush after the deep snows, the enchanted crags seem to float, appearing, vanishing in cloud, above the unbelievable delicacy of the forest.

Near or far, from its colossal rocks to its fragile meadows, Yosemite is always exquisite; it is one of the most pure and exquisite places in the world. Its scent is that of the incense cedar and its sound, except in drought or under ice, is that of water in all its voices. It is a place to return to throughout a lifetime, each time with a deeper joy and a more poignant love.

This book is one expression of such a lifetime of returning. Since 1916, when as a boy of fourteen with his first camera, Ansel Adams first beheld Yosemite, he has returned year after year, again and again, exploring, photographing, trying to express for others what is seen and felt here. He has come to know the Valley and the High Sierra above it in all hours and all weathers, in storm, in moonrise and the blazing radiance of noon; he can tell you when the sun will edge a particular cliff and when, in the mist of waterfalls, a rainbow will appear. To encompass such extremes of scale and light, he has developed a technique of extraordinary precision, range and flexibility. Much of this he summed up in an essay on mountain photography for his *My Camera in Yosemite Valley,* a bound portfolio of 24 fine reproductions which is now a collector's item. For the present book, this basic and invaluable information he has brought up to date and I as editor have chosen from the vast resource of his negatives a series presenting the salient moods and aspects of the Valley and its rim. Some of these images are classic; many have never been reproduced before. To these I could not resist adding one of the giant sequoias, another of the massive grandeur of Tenaya, a third of the peaks of the High Sierra under an autumn moon. While making this sequence I kept hearing lines from the earlier book; these I have made into a continuity which should accompany the photographs like a quiet voice.

To the beauty of Yosemite, whether in memory or in actuality, let a great photographer be your guide.

NANCY NEWHALL

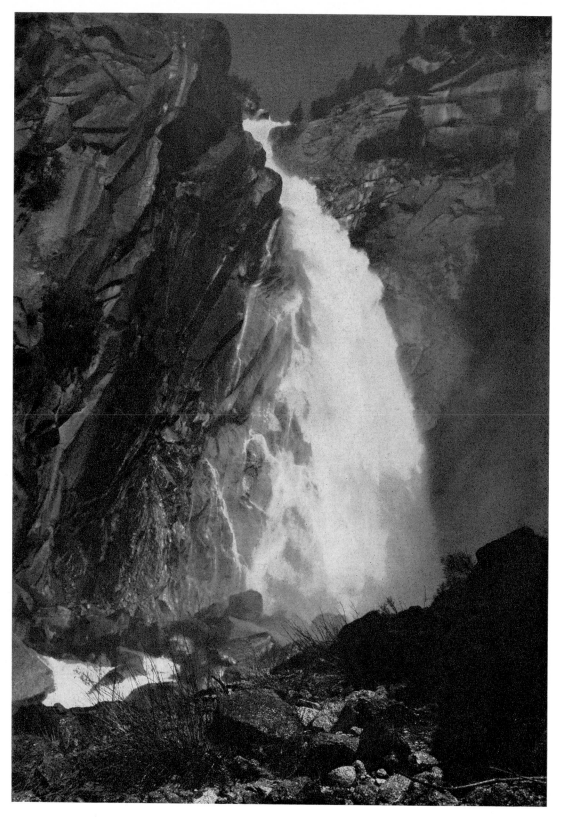

6. CASCADE FALL

Each waterfall retains its basic character at all times of flow —

each expressing an individual relationship of water and stone,

each developing its vital patterns of descent and impact.

Each great rock is distinctive in form and surface.

The three-thousand-foot cliff of El Capitan

is overpowering in sheer colossal form.

7. CLIFF FACE, AFTERNOON—EL CAPITAN

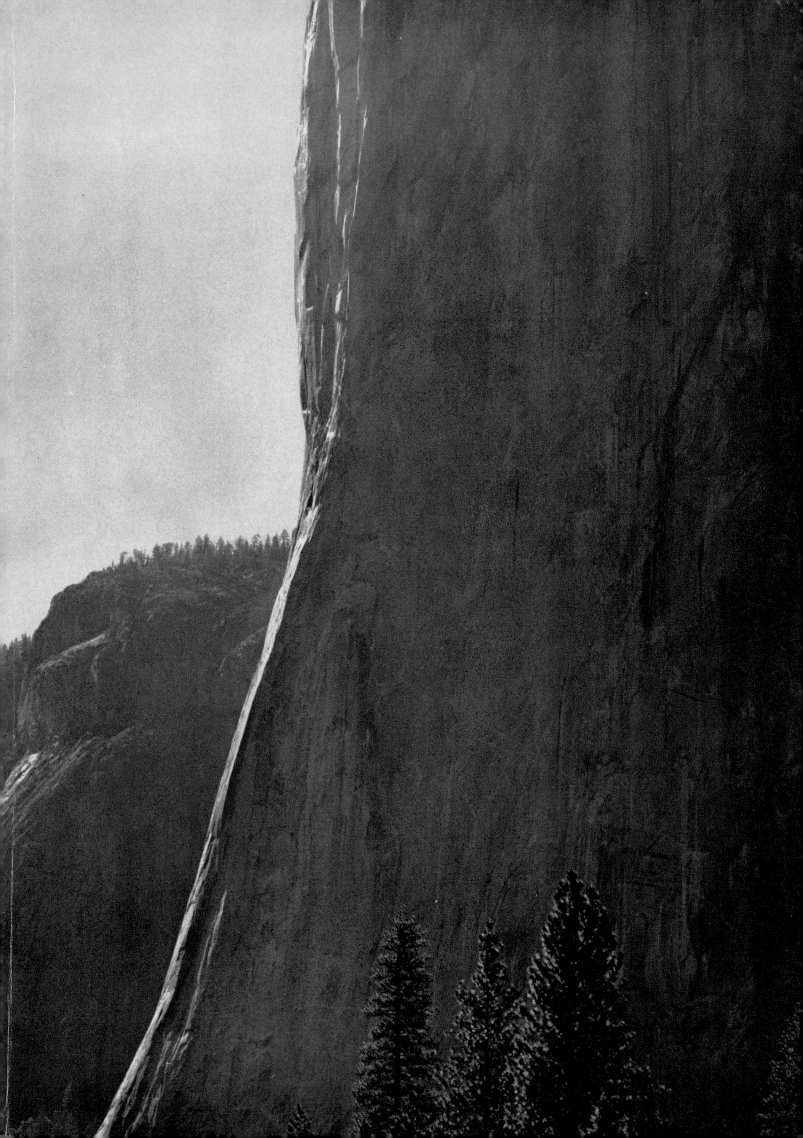

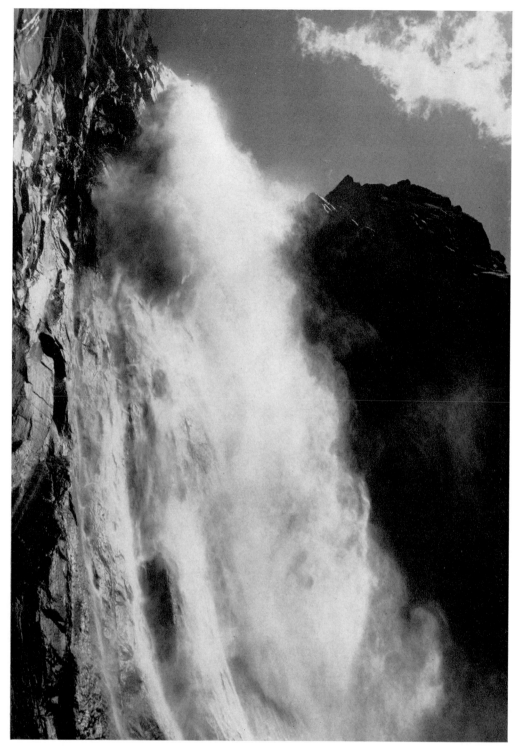

8. *TOP OF RIBBON FALL*

A waterfall is but an episode in the life of a whole singing stream,

pouring from the high stone fountains of the summit peaks

to the blending with the great river below.

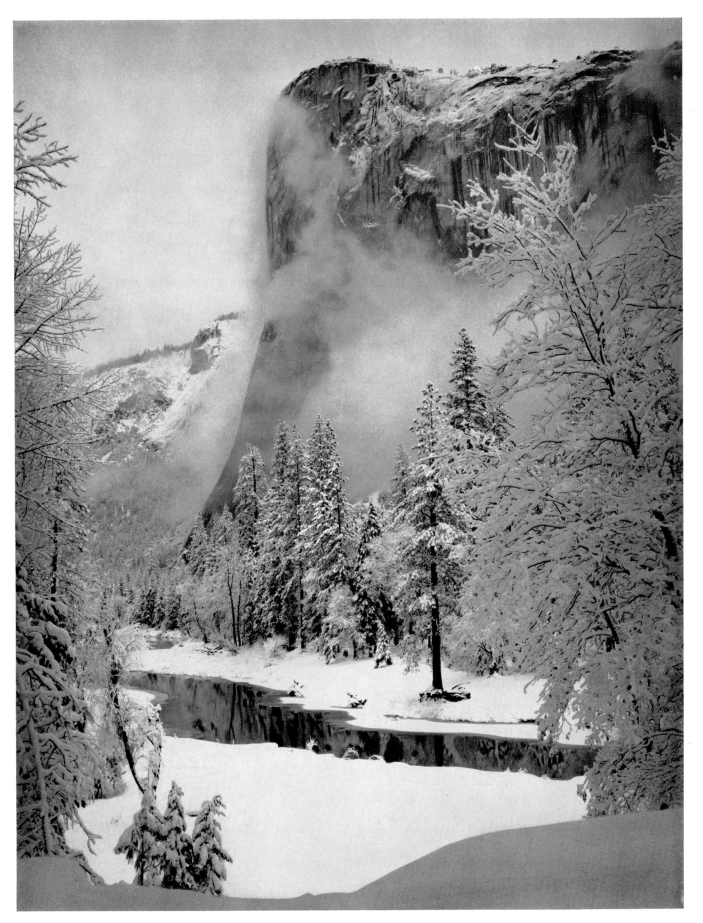

One of the great charms of Yosemite lies in the contrasts
between the severity of the great rocks, the power of the waterfalls,
and the delicacy of the forests.

Bridalveil Fall even in highest flood, retains a mood of delicacy.

The great rocks rise with gigantic weight against the sun

but never is there blackness — absence of light — upon them.

Even half-hidden shadowed places vibrate with a quiet luminescence.

10. MORNING MIST AT THE GATES OF THE VALLEY

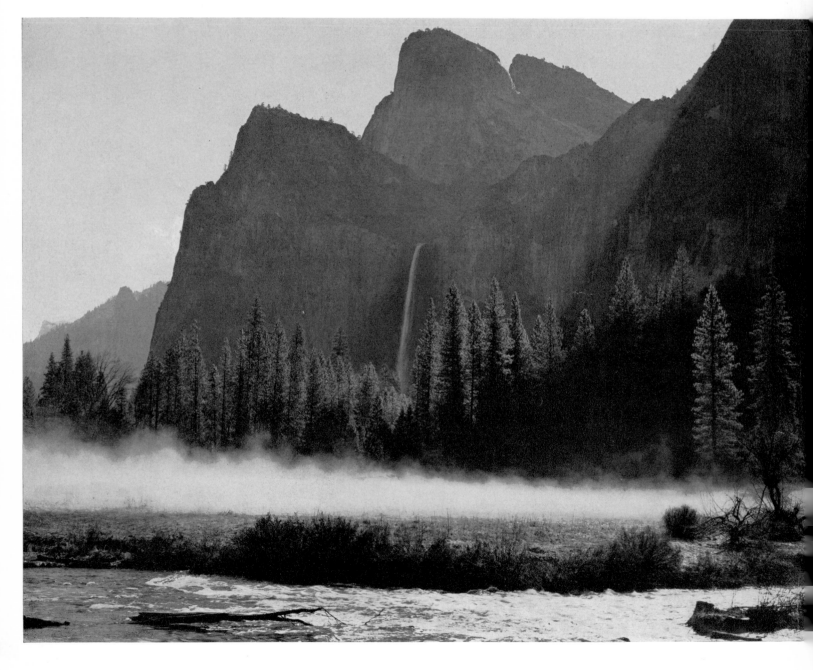

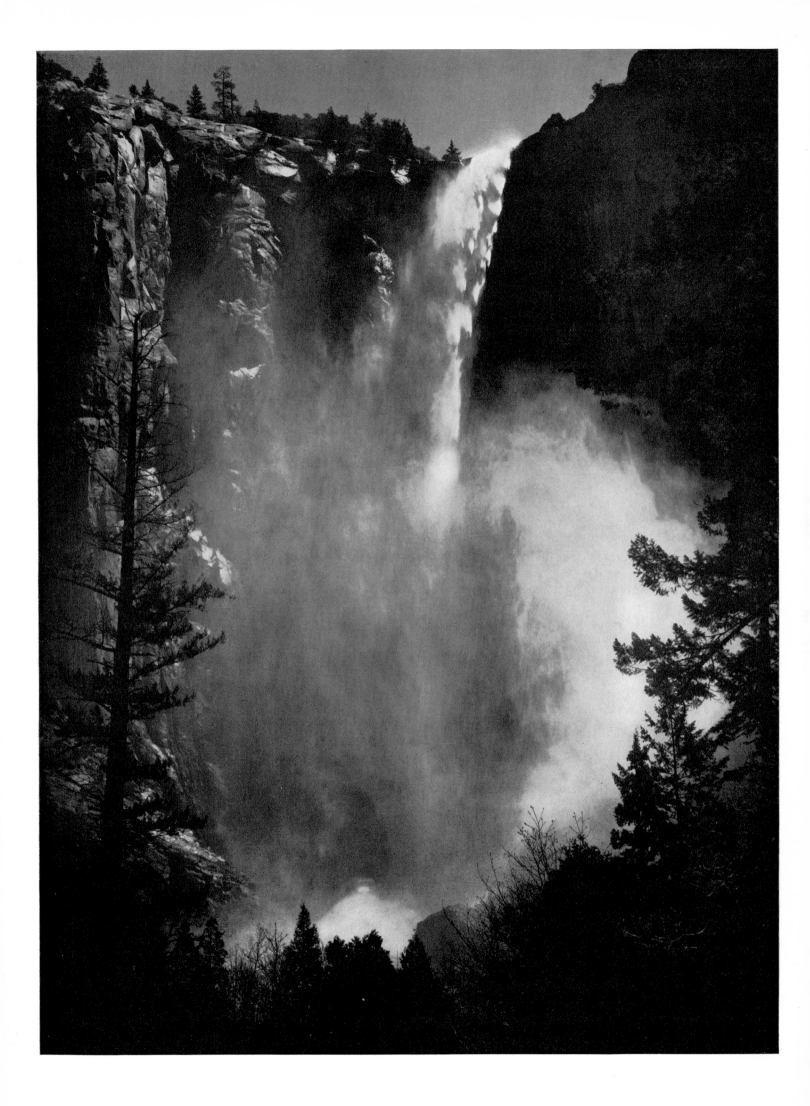

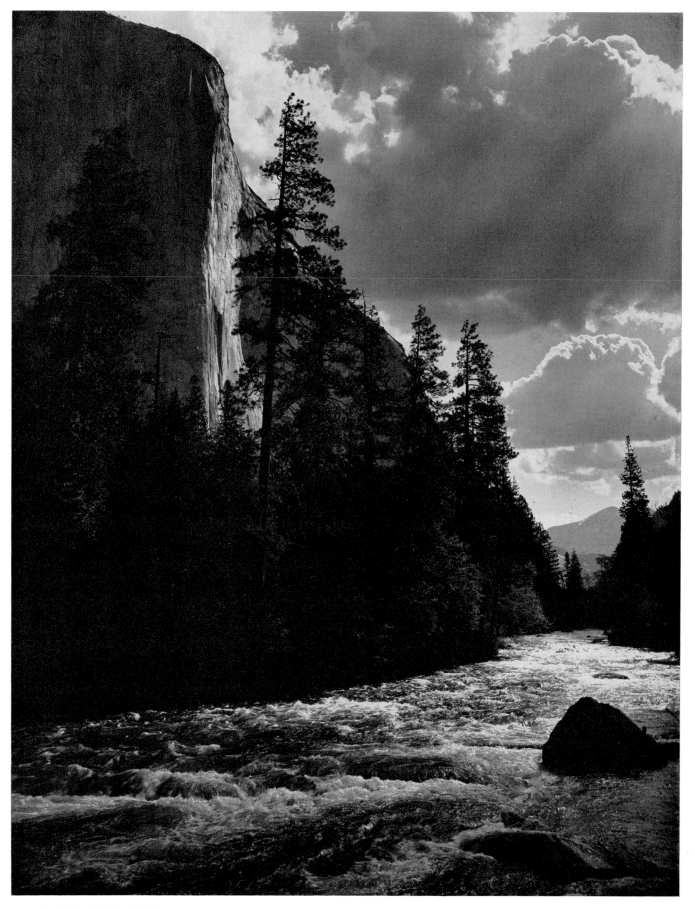

12. THE MERCED RIVER

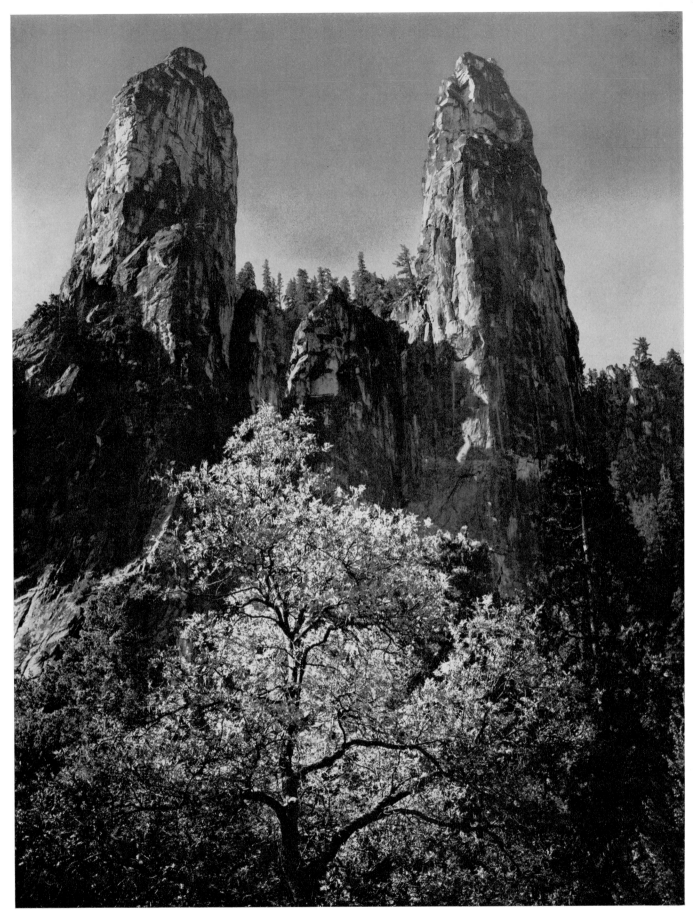

13. *CATHEDRAL SPIRES*

Morning—at any time of year—is the time of magic in the mountains.

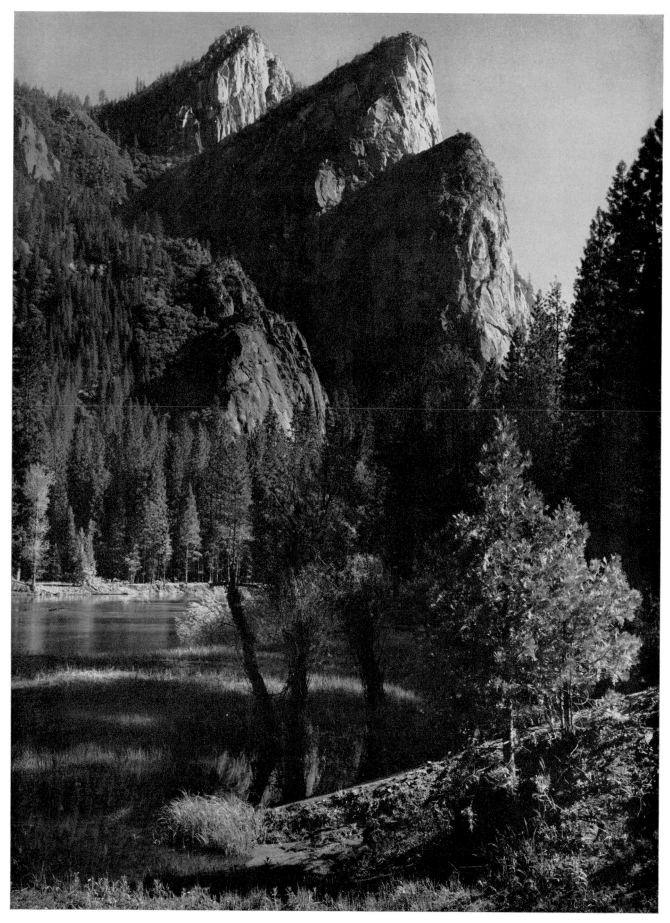

14. *THREE BROTHERS*

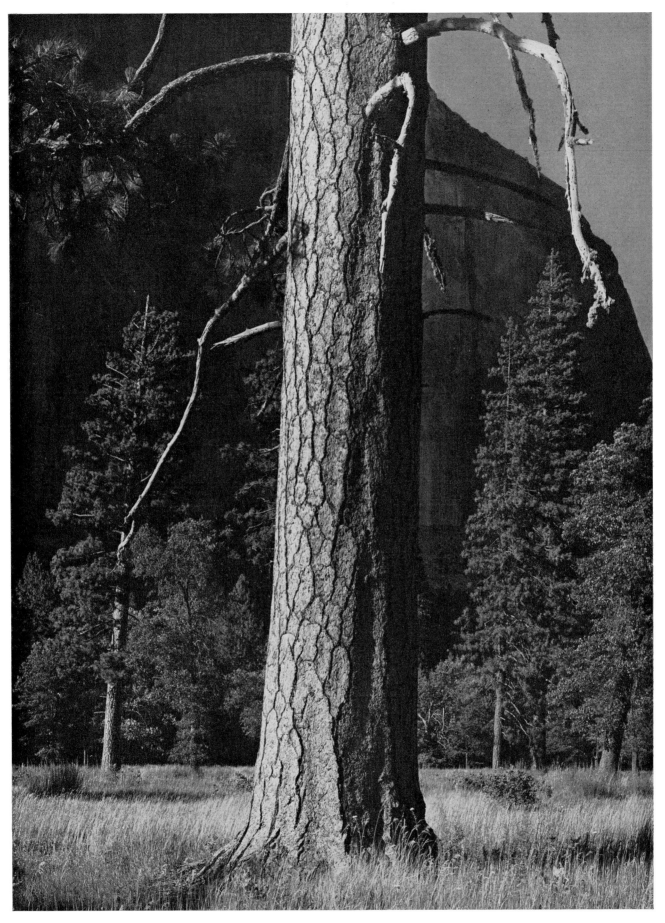

15. YELLOW PINE TREE, EL CAPITAN MEADOW

Do not be content to stop at the popular viewpoints.

Walk in the cool forests and by the rivers and streams and

watch the great rocks reveal themselves in endless and varied character.

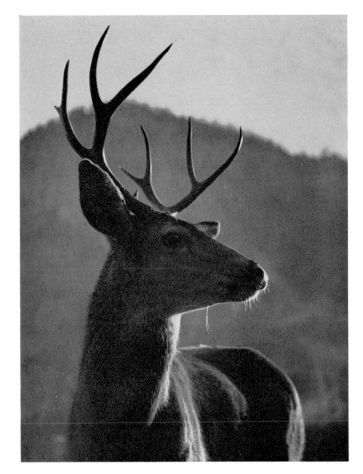

16. *BUCK*

17. *INDIAN MORTAR HOLES*

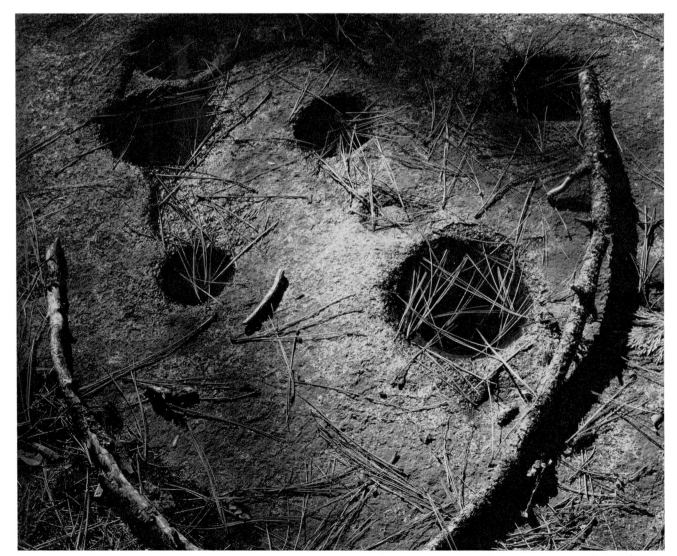

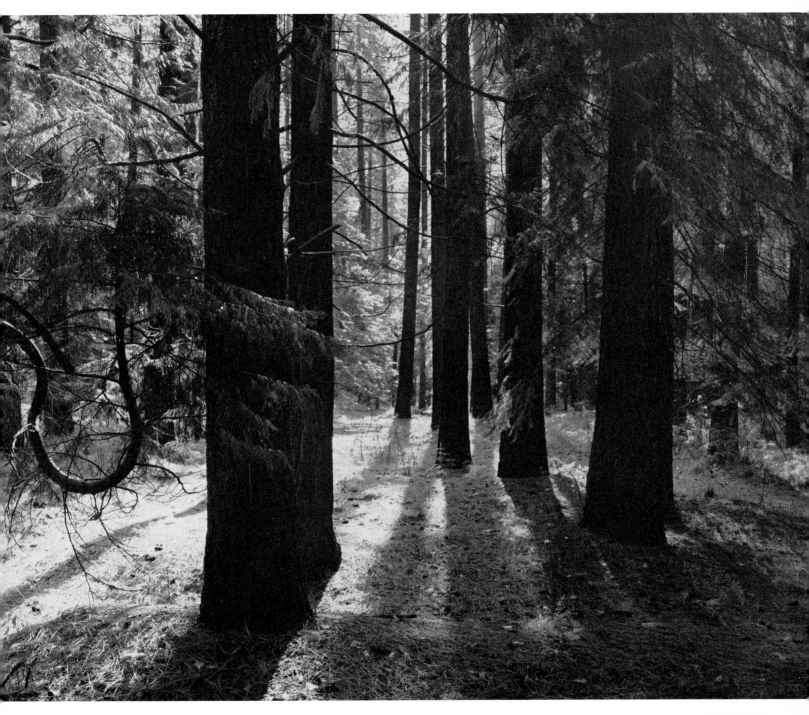

Walk upon the stones and pine needles, smell the fragrance of

meadows and forests, touch the branches of trees.

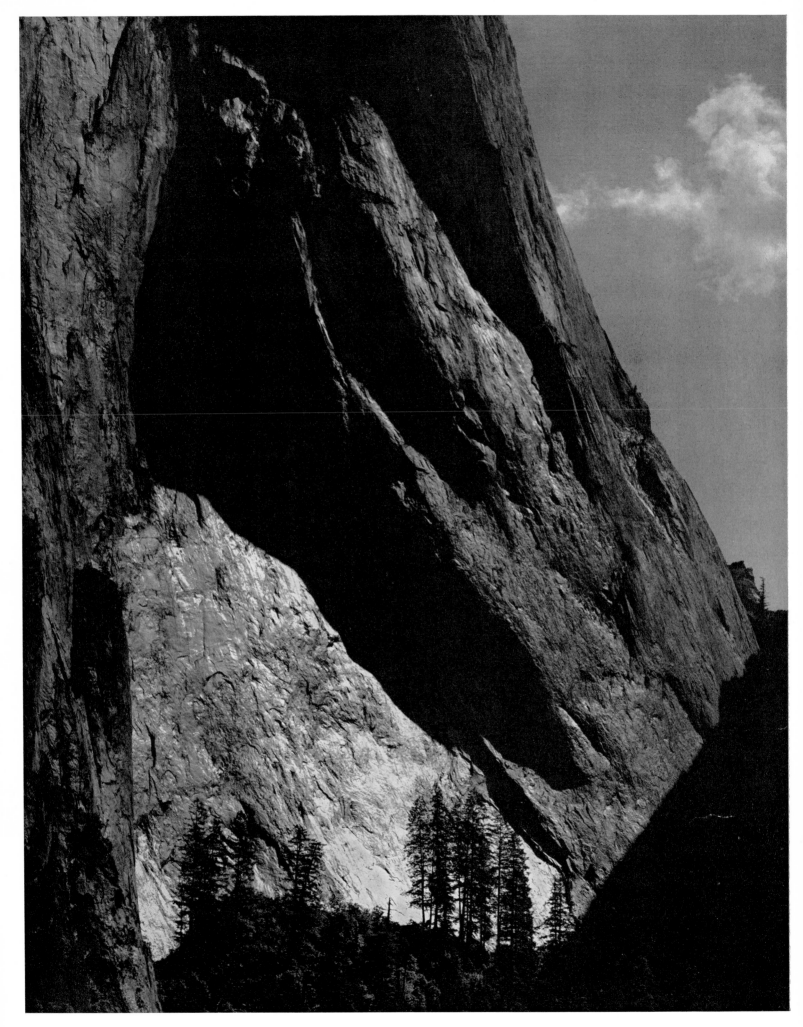

19. CLIFFS, CATHEDRAL ROCKS

Usually clear under the decisive Sierra sun, the Valley sometimes
acquires nostalgic moods of storm cloud and haze; in the afternoons
westerly winds bring summer haze from the foothills and lowlands,
and the borders of high mountain thunderstorms reach over the Valley.

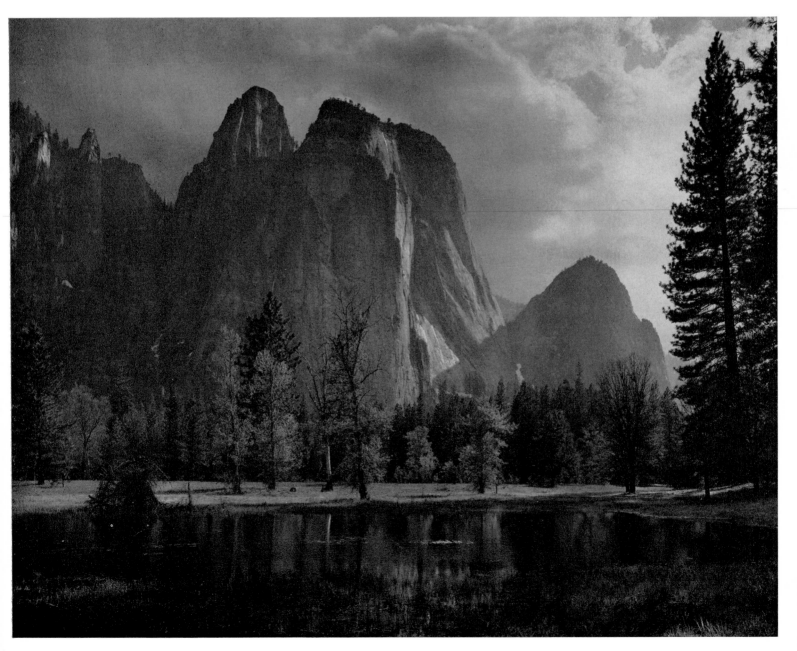

20. CATHEDRAL ROCKS, AFTERNOON STORM

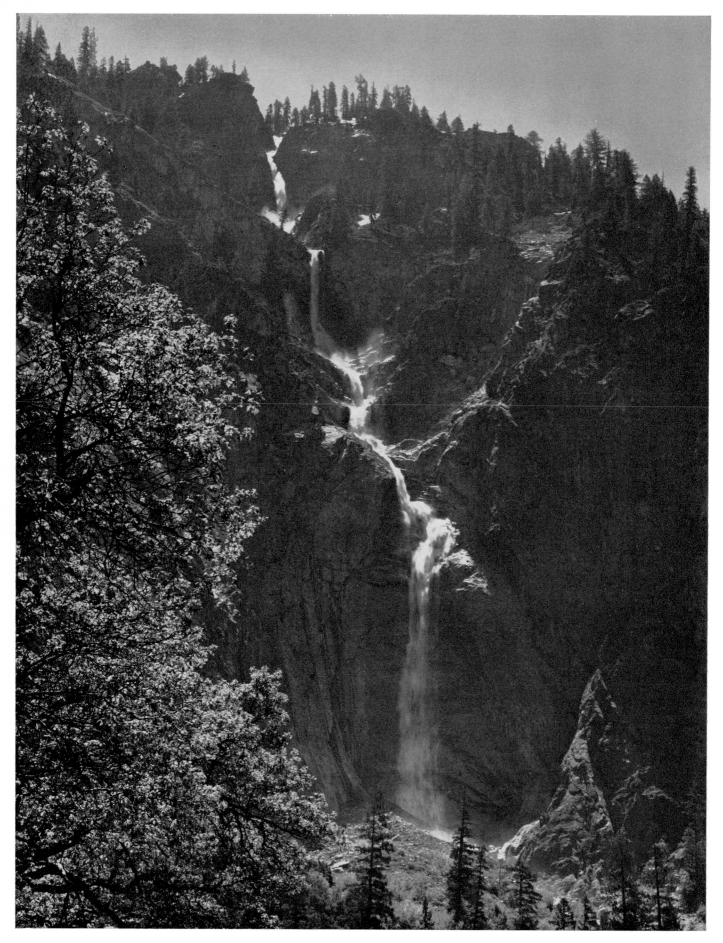

21. *SENTINEL FALLS*

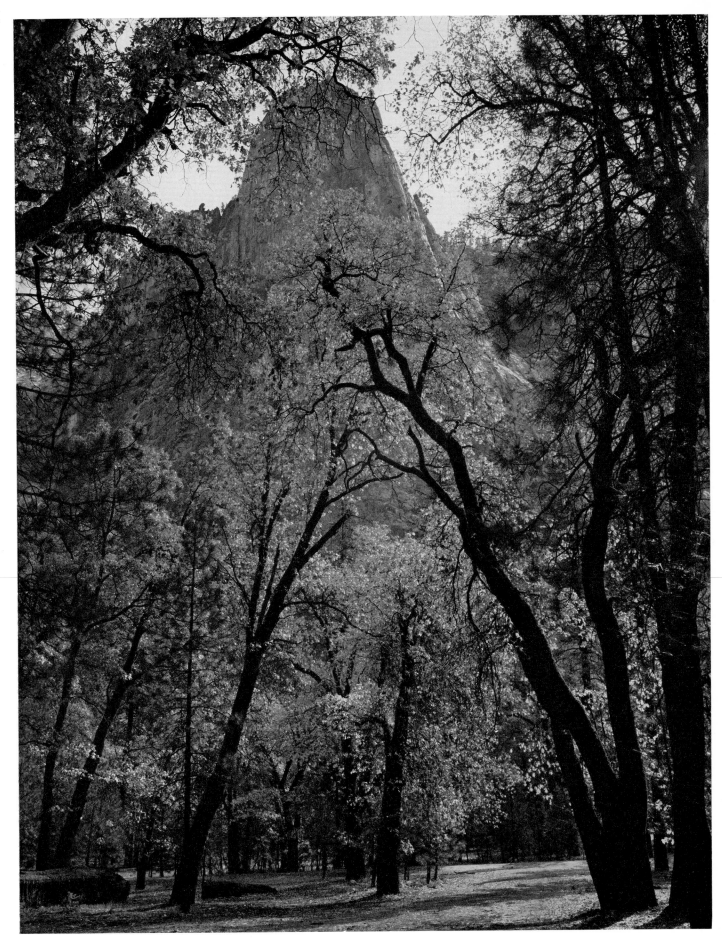

22. SENTINEL ROCK, AUTUMN

In Autumn, the warm aura of the forest contrasts sharply

with the steel-cold stone and sky.

Wreathed in clouds, isolated grandly in gray space, this great rock

assumes the intricate qualities of a Gothic spire.

Go where you will along the river banks, up the talus slopes,

through the live oaks — you will find the moods of the quieter

living things of the earth finest when they are bright with dew or

at dusk when the wind has quieted and the light is soft and penetrating.

23. RIVER AT VALLEY VIEW, AUTUMN

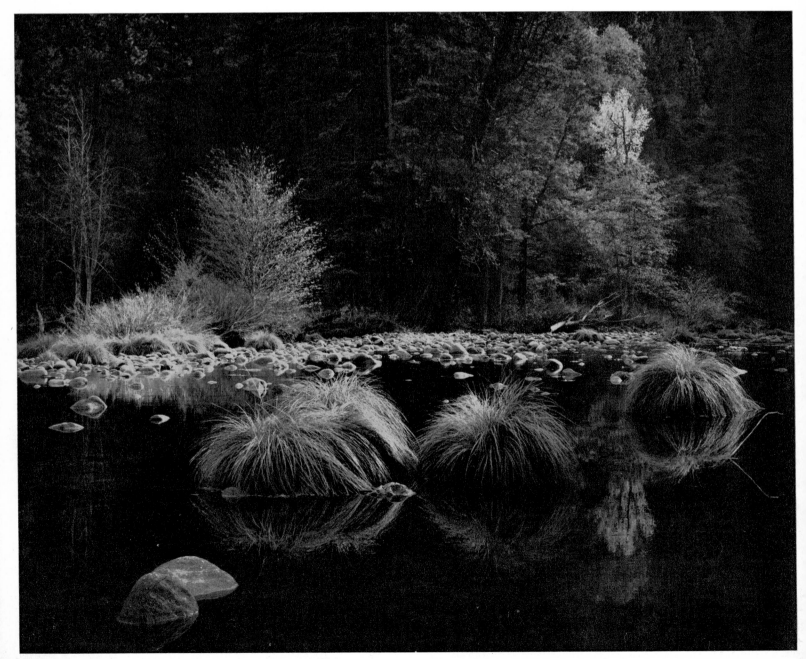

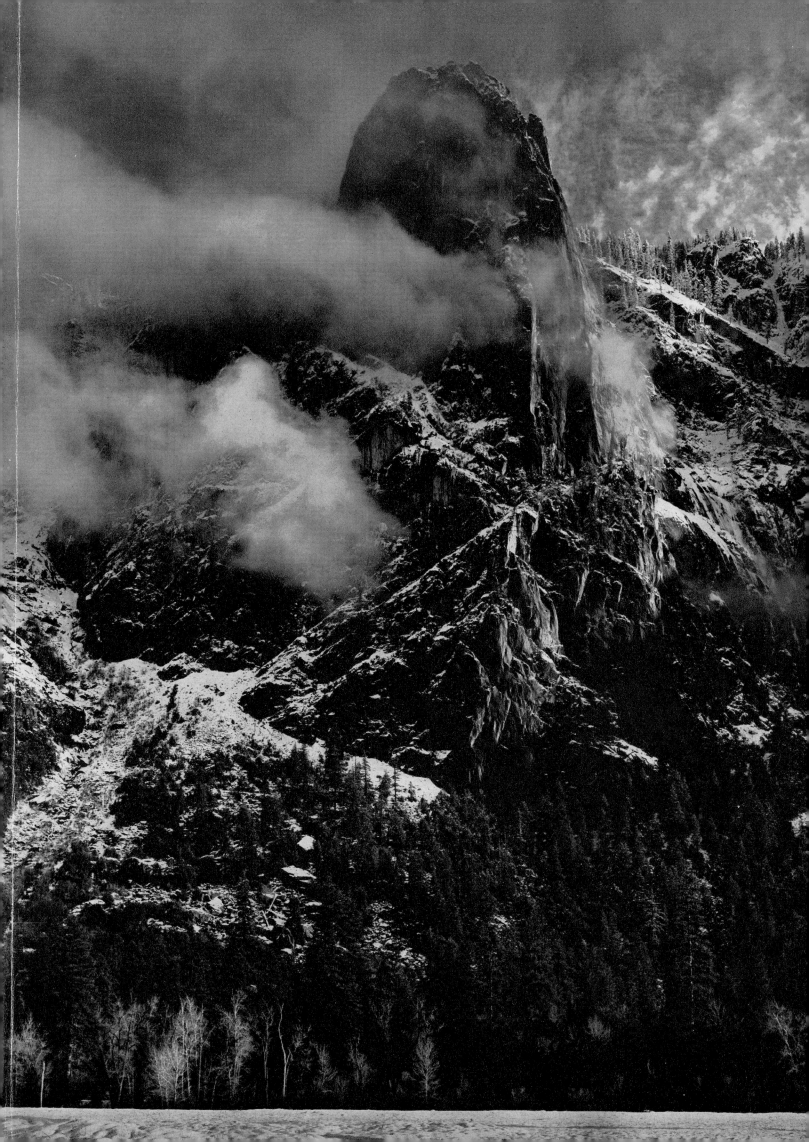

The Yosemite Falls express
 a daring jubilancy —

a leaping, pounding force
 in early spring, a swaying,

floating wraith in late summer.

25. YOSEMITE FALLS

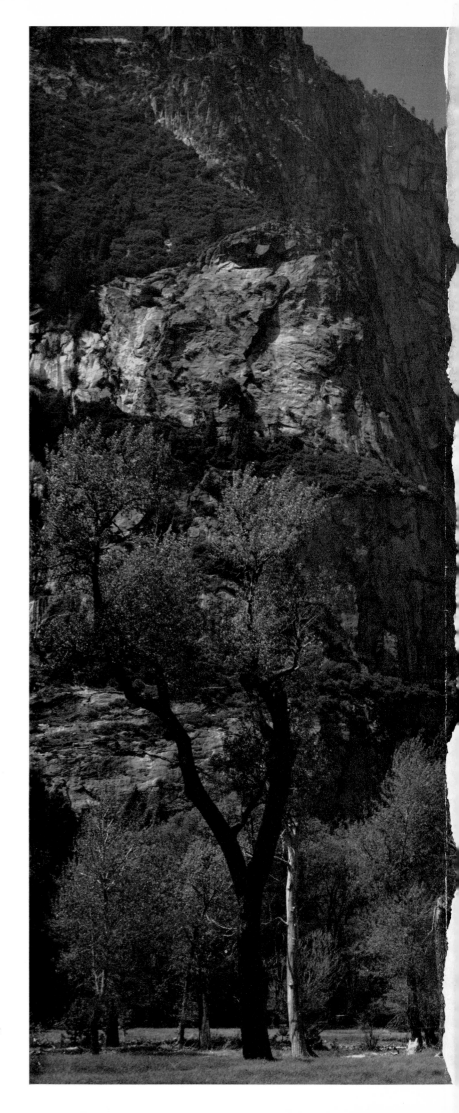

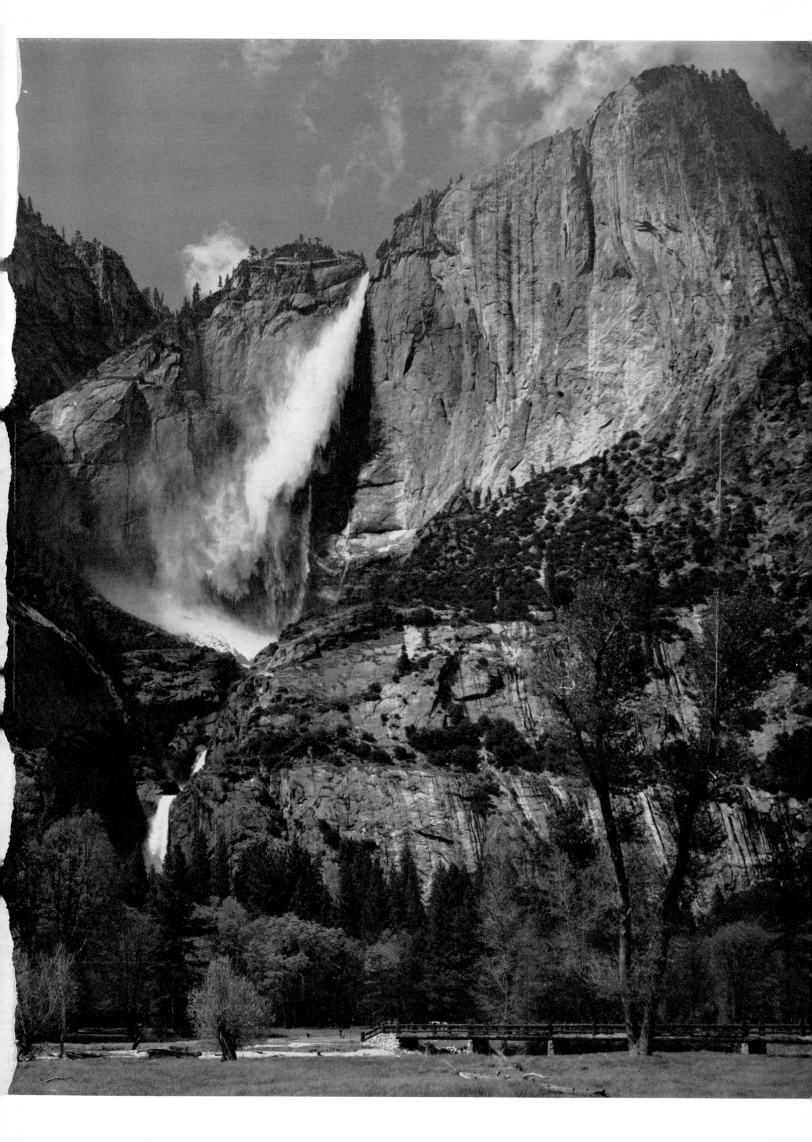

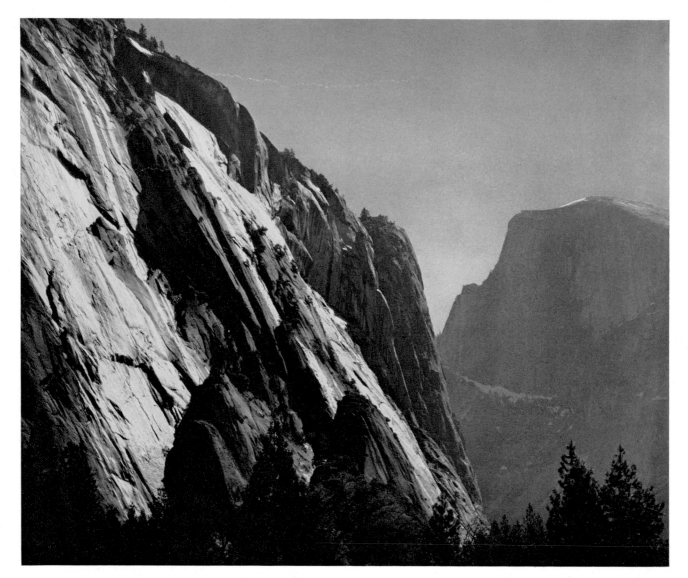

26. ROYAL ARCHES CLIFFS AND HALF DOME

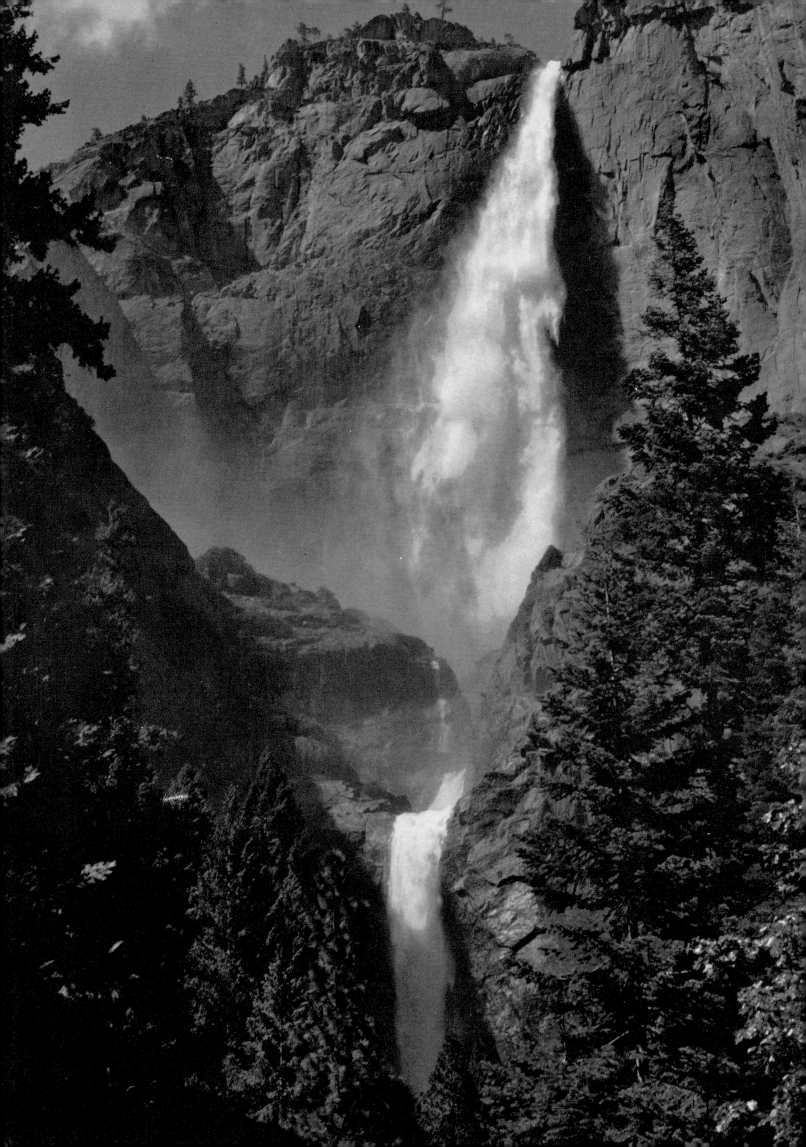

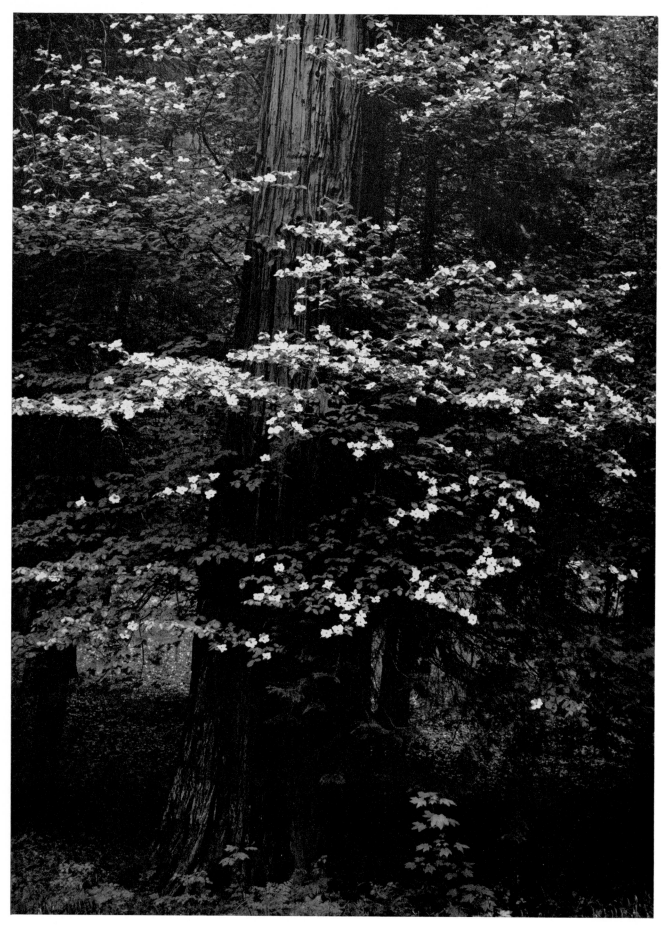

28. *DOGWOOD BLOSSOMS, NEAR BRIDALVEIL FALL*

In Spring, the forest shines with the stars of the Pacific Dogwood.

As dusk approaches, their intensity increases;

they float in the dark spaces like scintillating points of light.

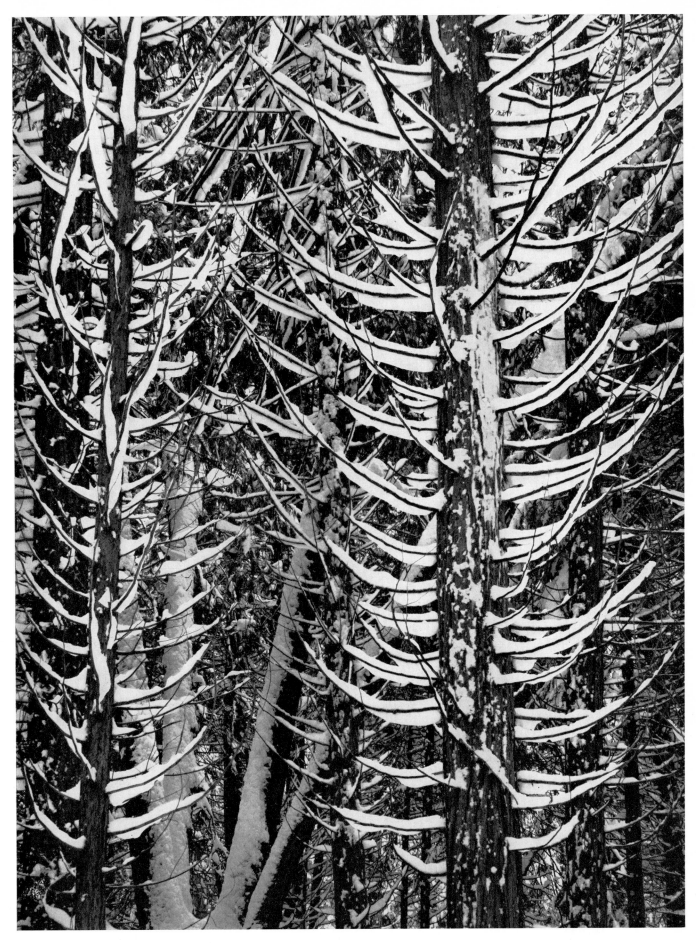

29. *WINTER FOREST*

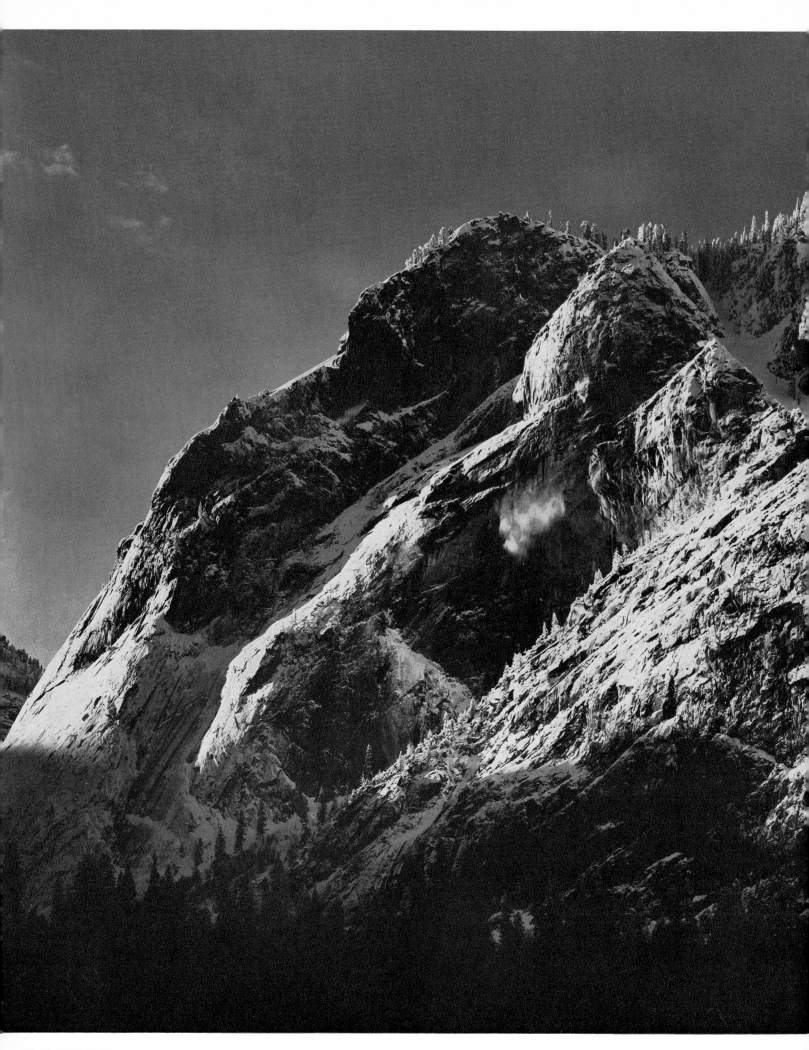

30. *GLACIER POINT*

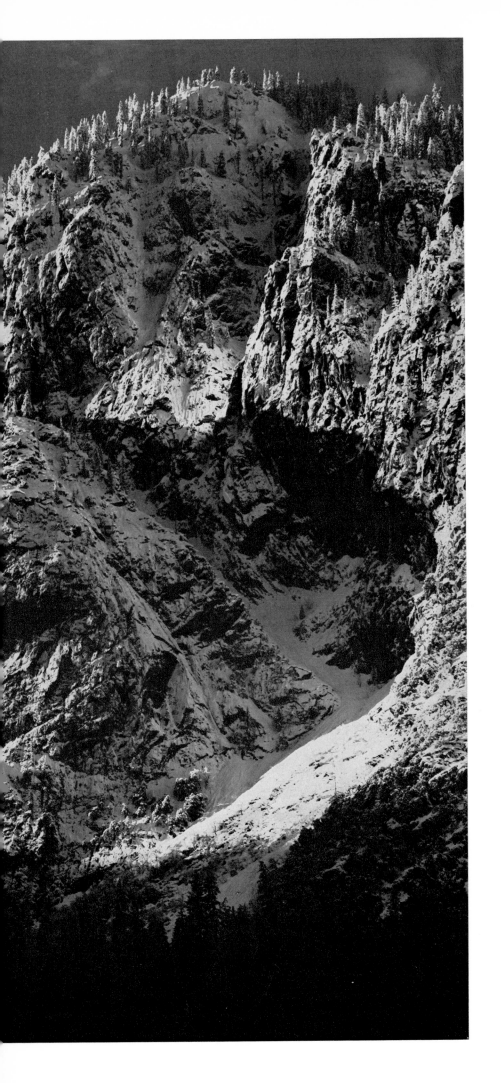

Glacier Point, like the
 development of a great fugue,

is the climax of the south wall
 of Yosemite.

In Winter, after a driving storm,
 its face is frosted with ice,

yet at the first touch of sun
 the snow and ice will crumble

and roar down the cliff faces
 and the gullies in jubilant
 avalanches.

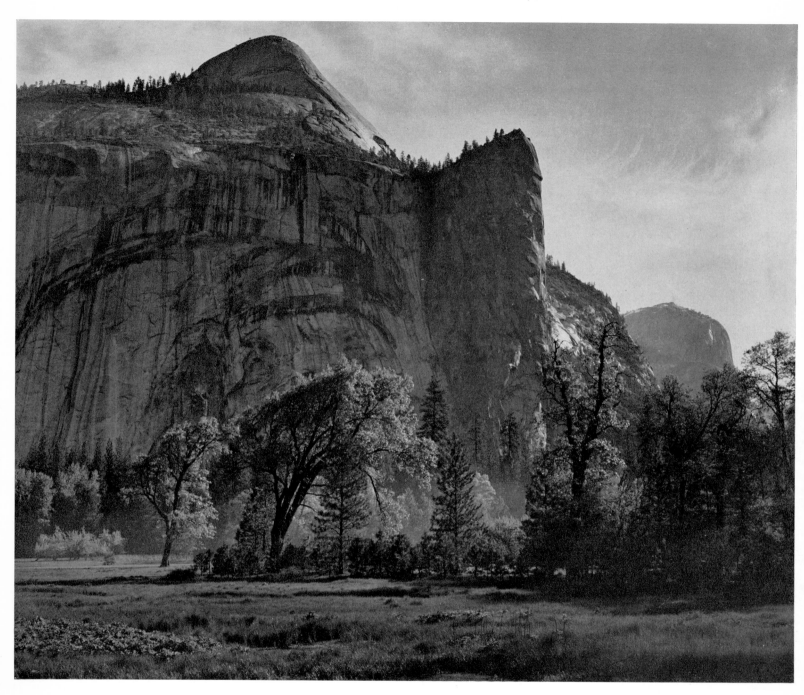

31. *NORTH DOME, ROYAL ARCHES, WASHINGTON COLUMN*

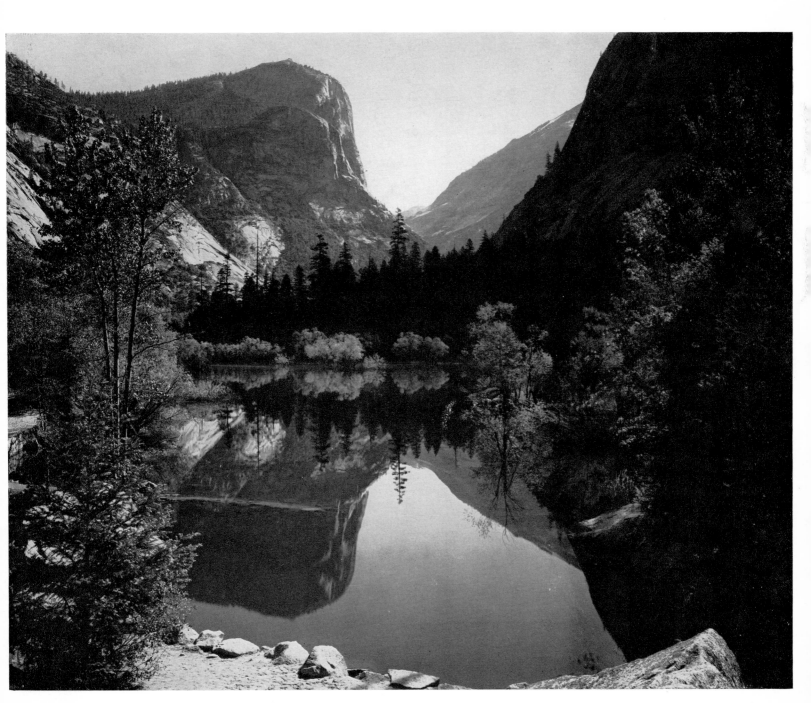

32. *MIRROR LAKE, EARLY SPRING*

The enormous and the minute emerge into one vibrant unity —

the spirit and beauty of Yosemite.

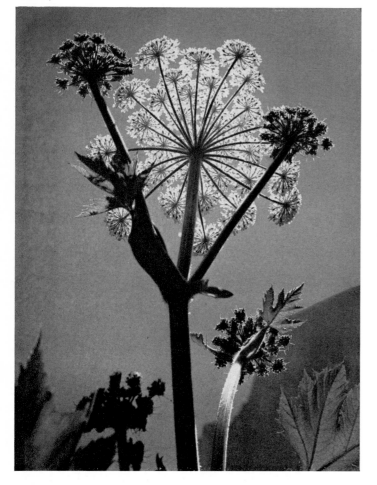

33. FLOWER AND HALF DOME

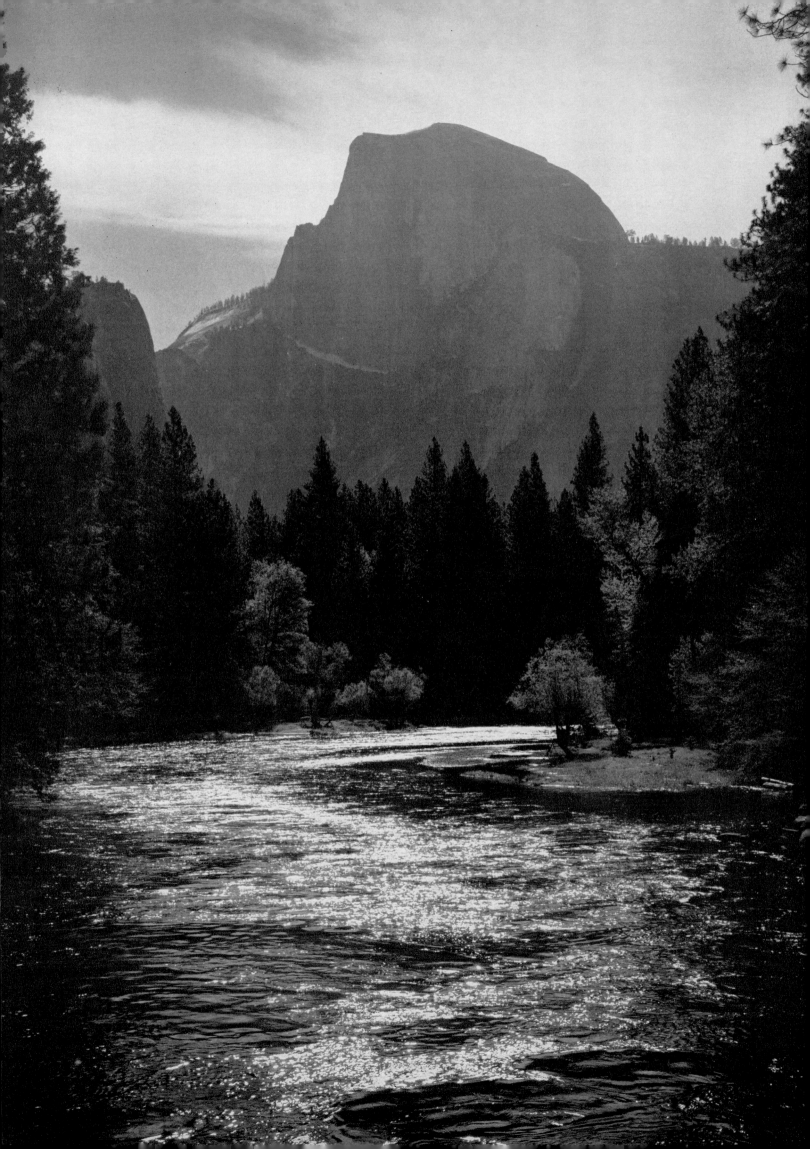

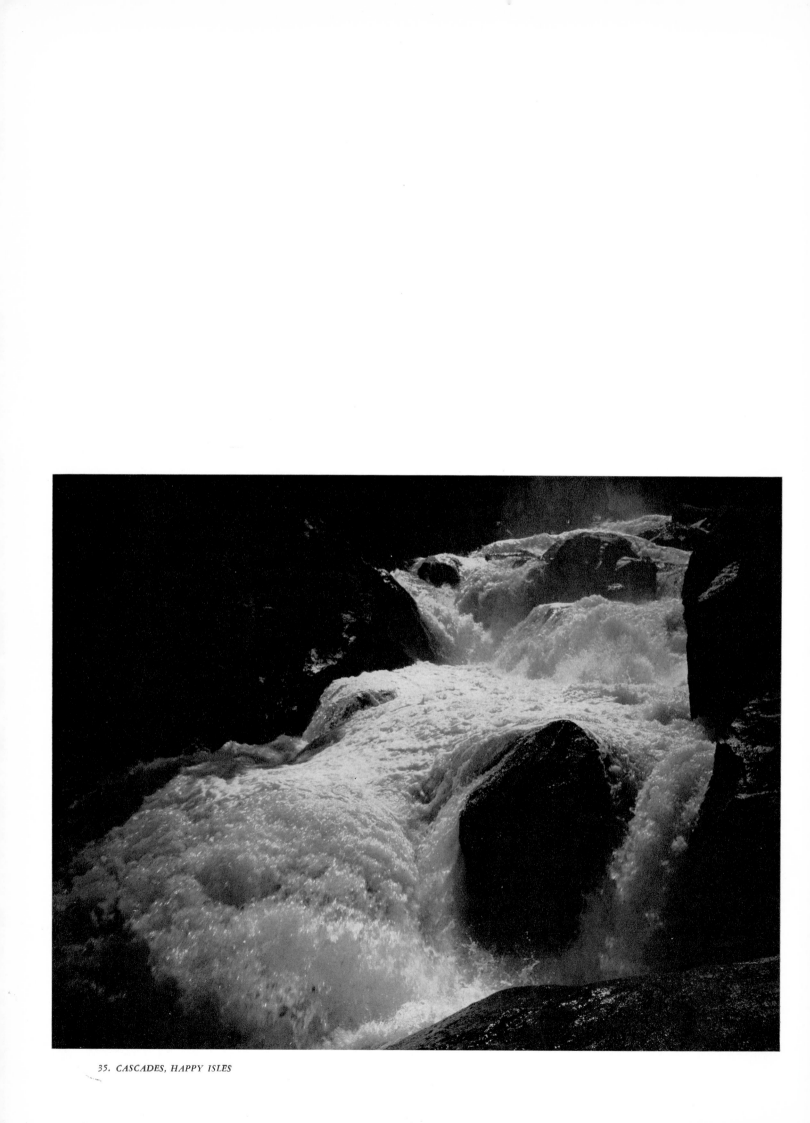

35. CASCADES, HAPPY ISLES

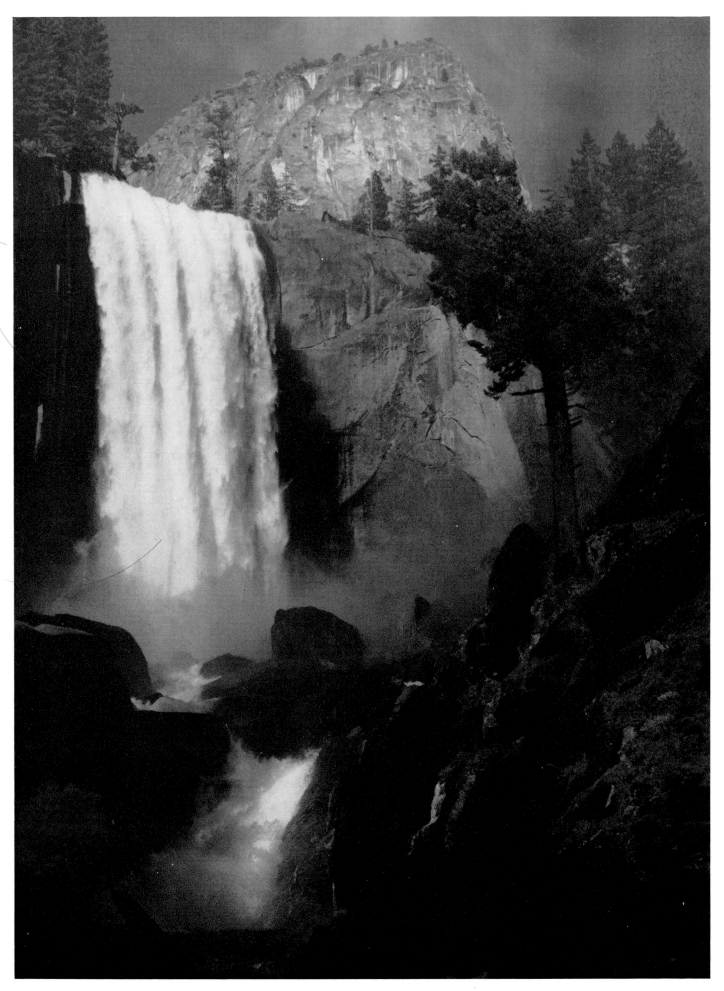

36. *VERNAL FALL*

Nevada Fall, in thundering flood, is the supreme expression
of the massive power of water in Yosemite.

37. *NEVADA FALL*

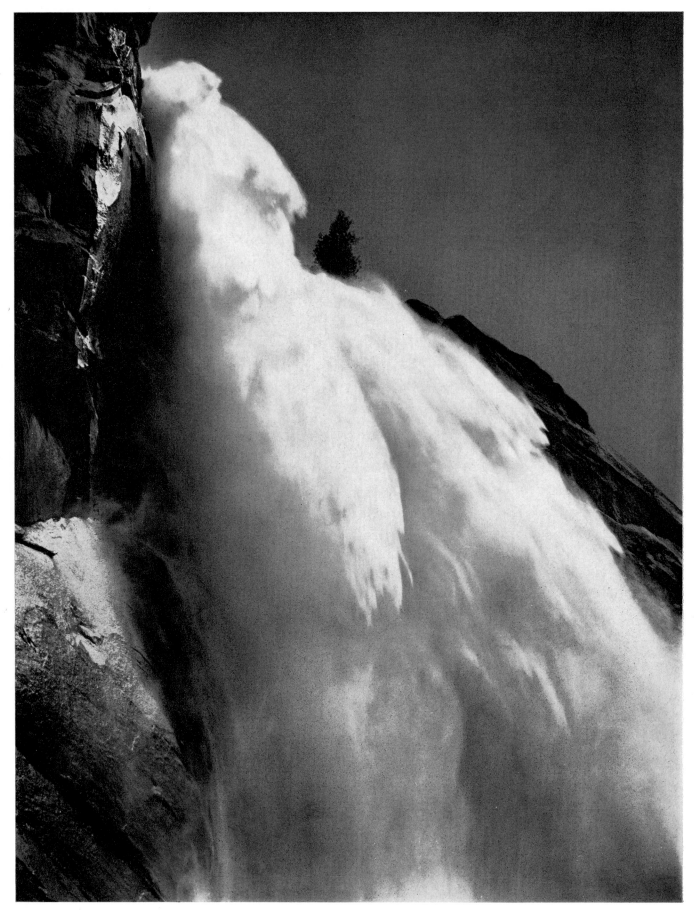

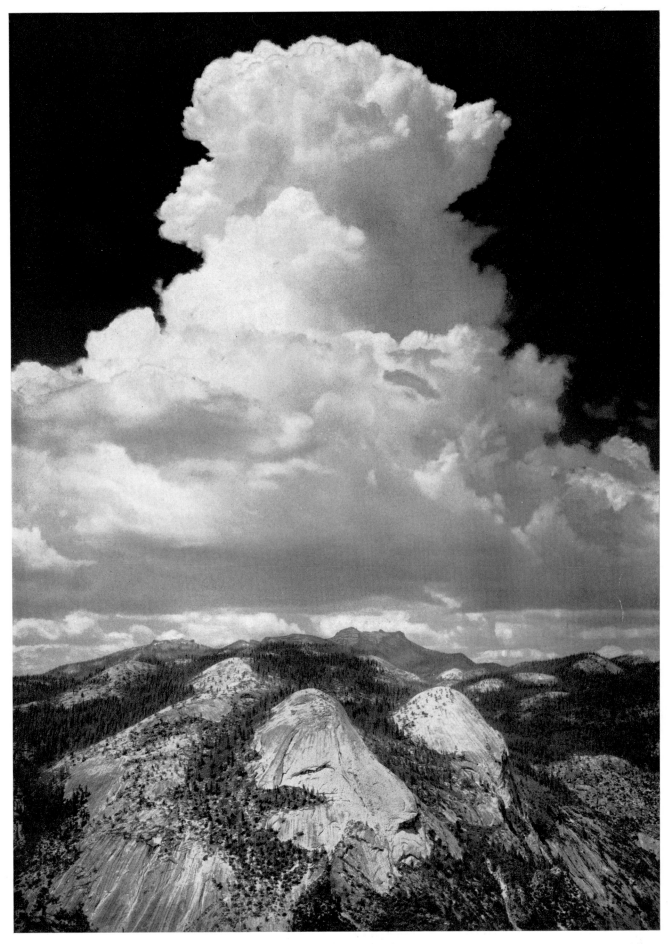

38. NORTH DOME, THUNDERHEAD, FROM GLACIER POINT

In Summer the vast Sierra skies are thronged with massive mountains of clouds.

They tower and flow, with stately patience, and give appropriate voice

and the offering of rain to the spaces of stone and sky in which they move.

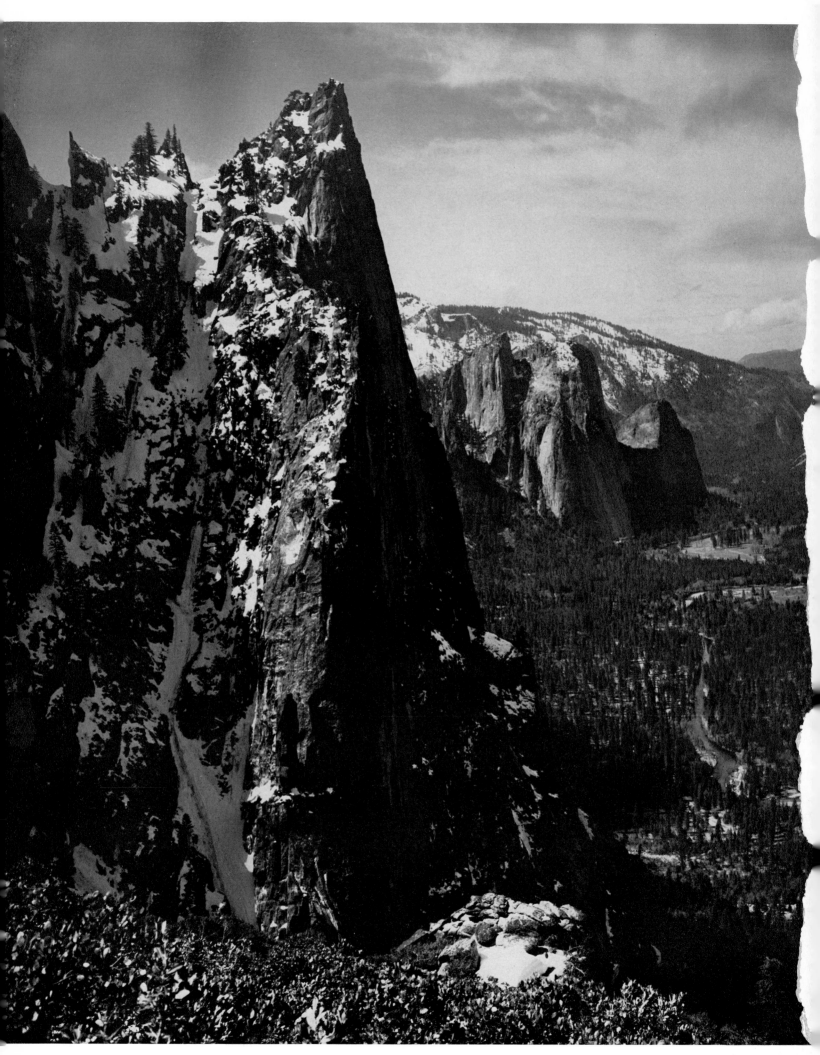

39. *THE LOWER VALLEY FROM THE GLACIER POINT TRAIL*

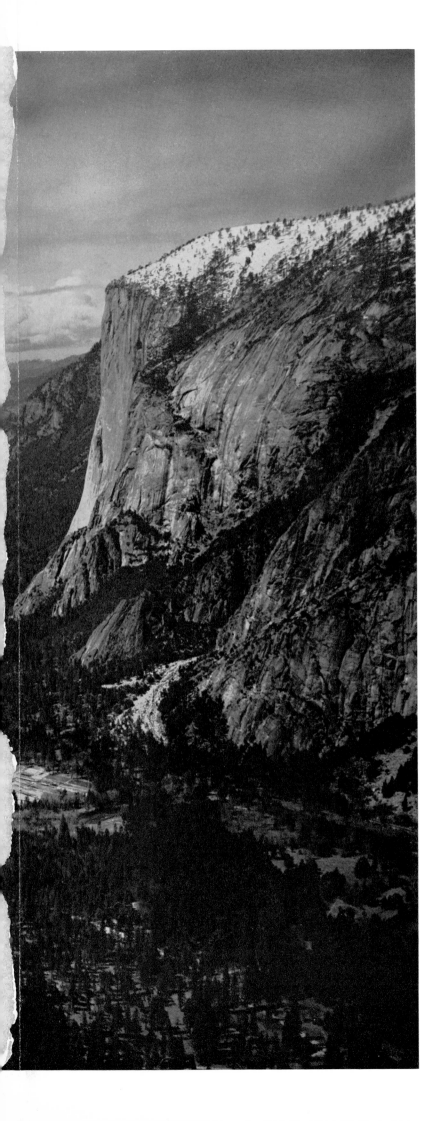

Boldly advancing from the
matrix of the mountains,

towering thousands of feet
into the sky,

the great rocks dwarf every
conceivable structure of man.

Of tremendous strength and endurance,
its form is evidence

of the constant flow of wind over the Dome.

When the great storms drift down
from the high mountains,

clouds place the grand outlines
of the Dome in strong relief.

40. JEFFREY PINE ON SENTINEL DOME

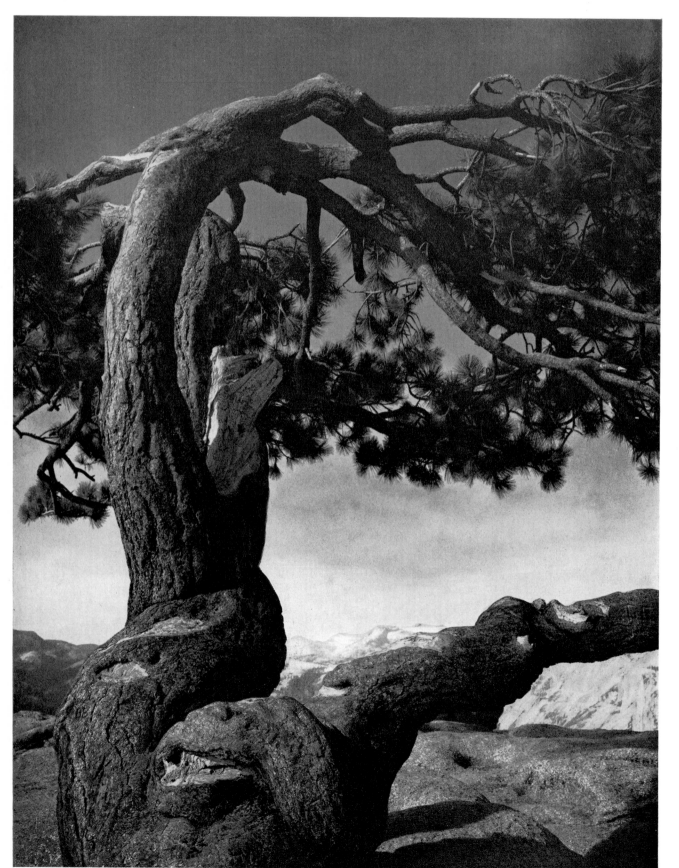

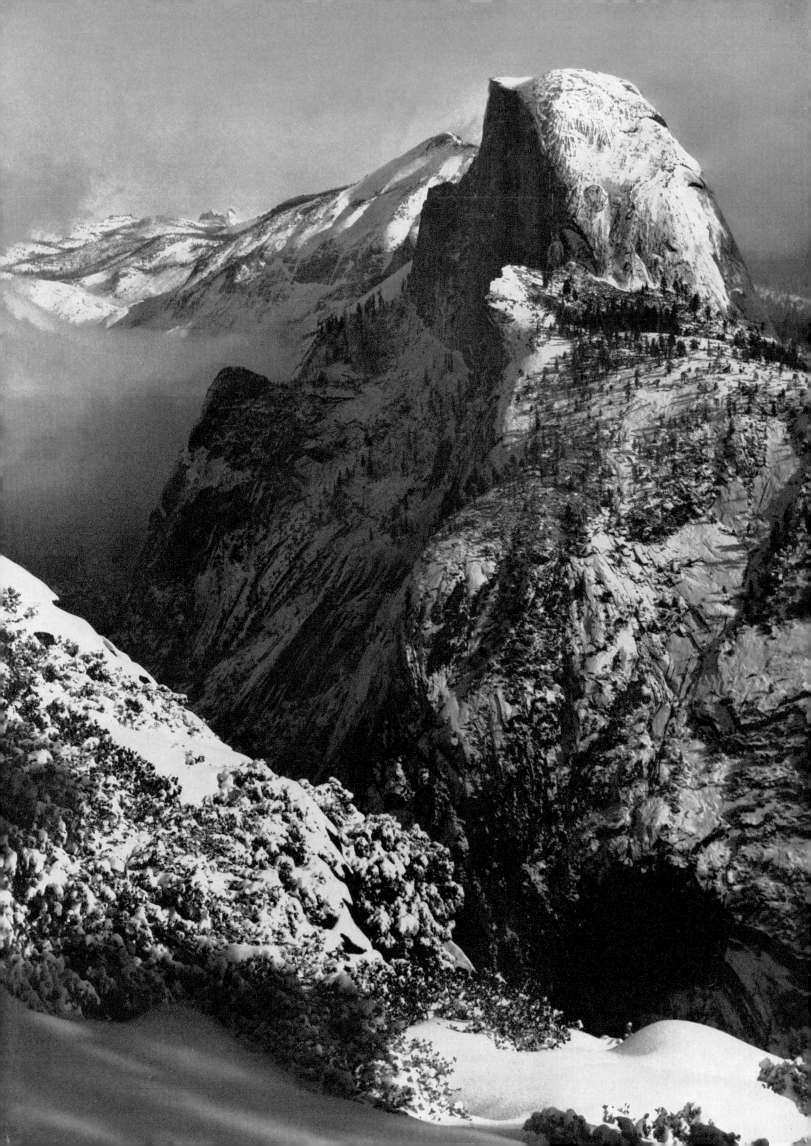

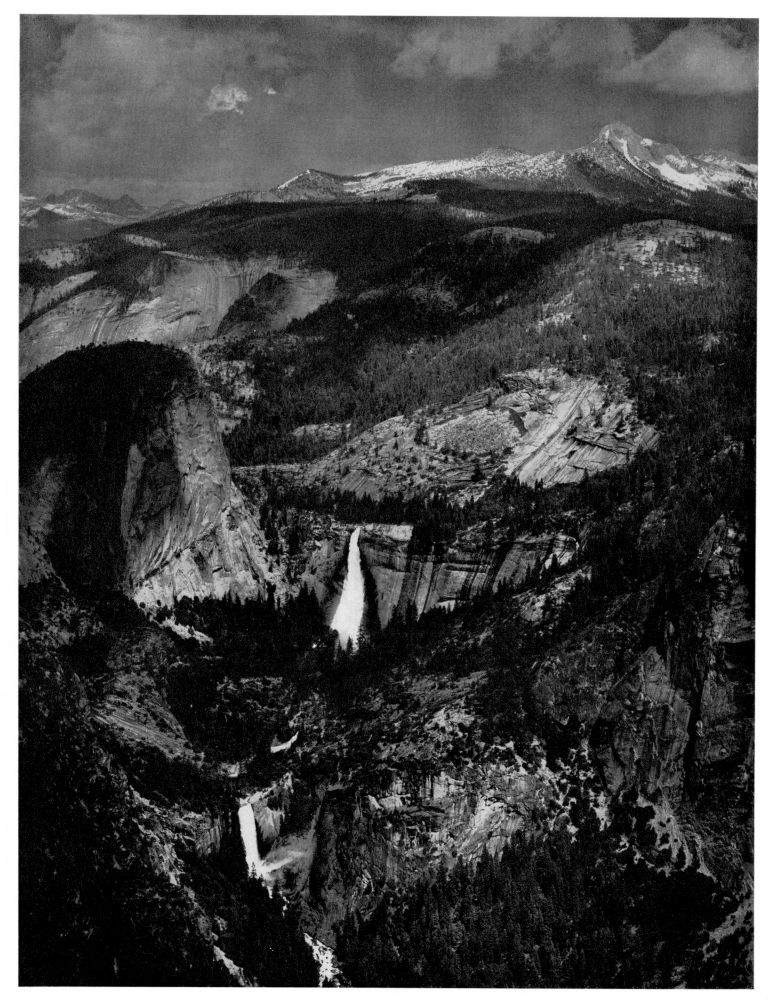

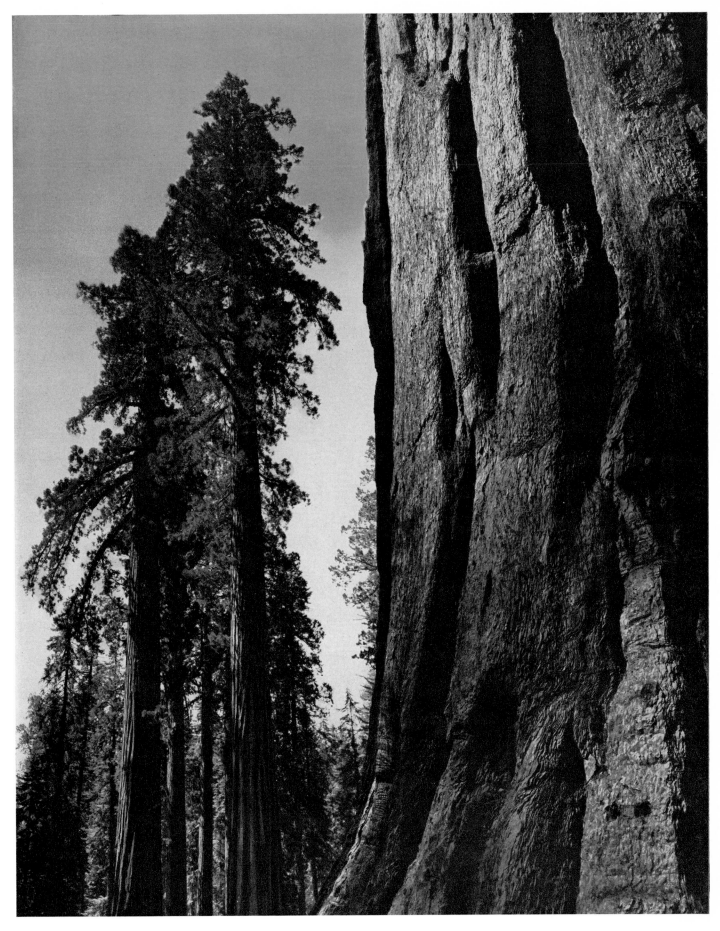

43. GIANT SEQUOIAS, MARIPOSA GROVE

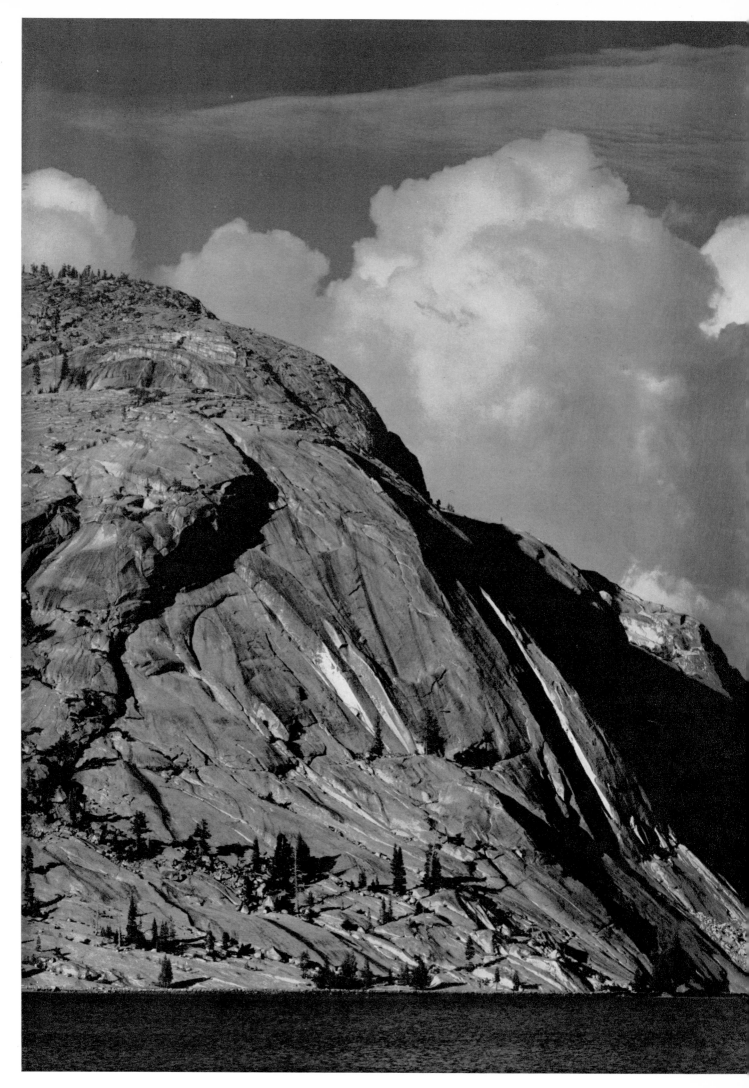

44. *LAKE TENAYA, ON THE TIOGA ROAD*

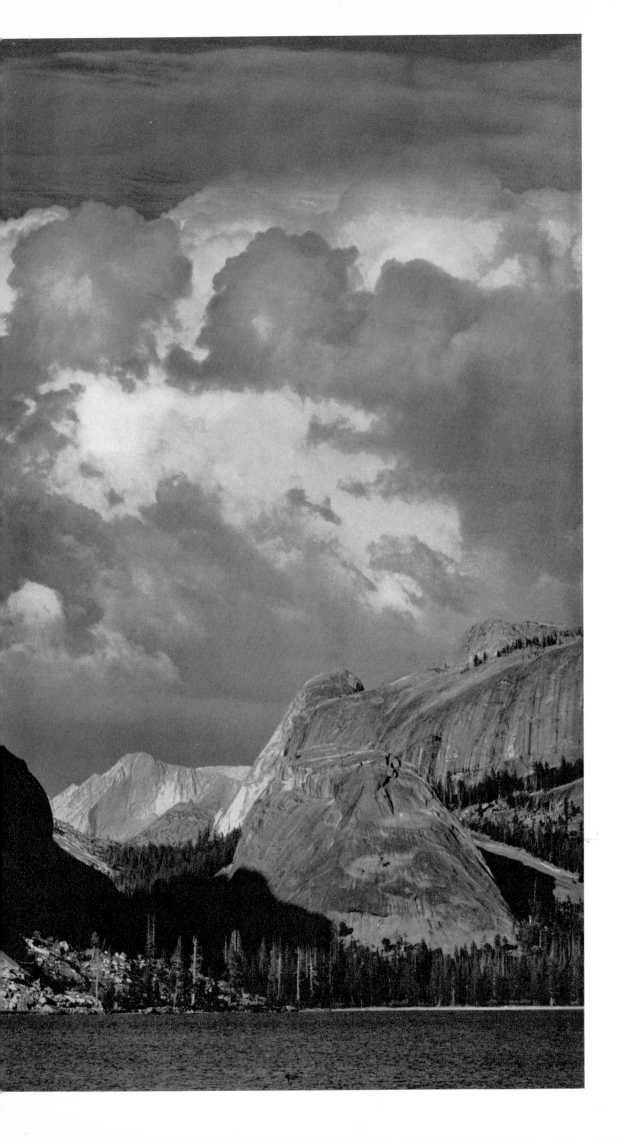

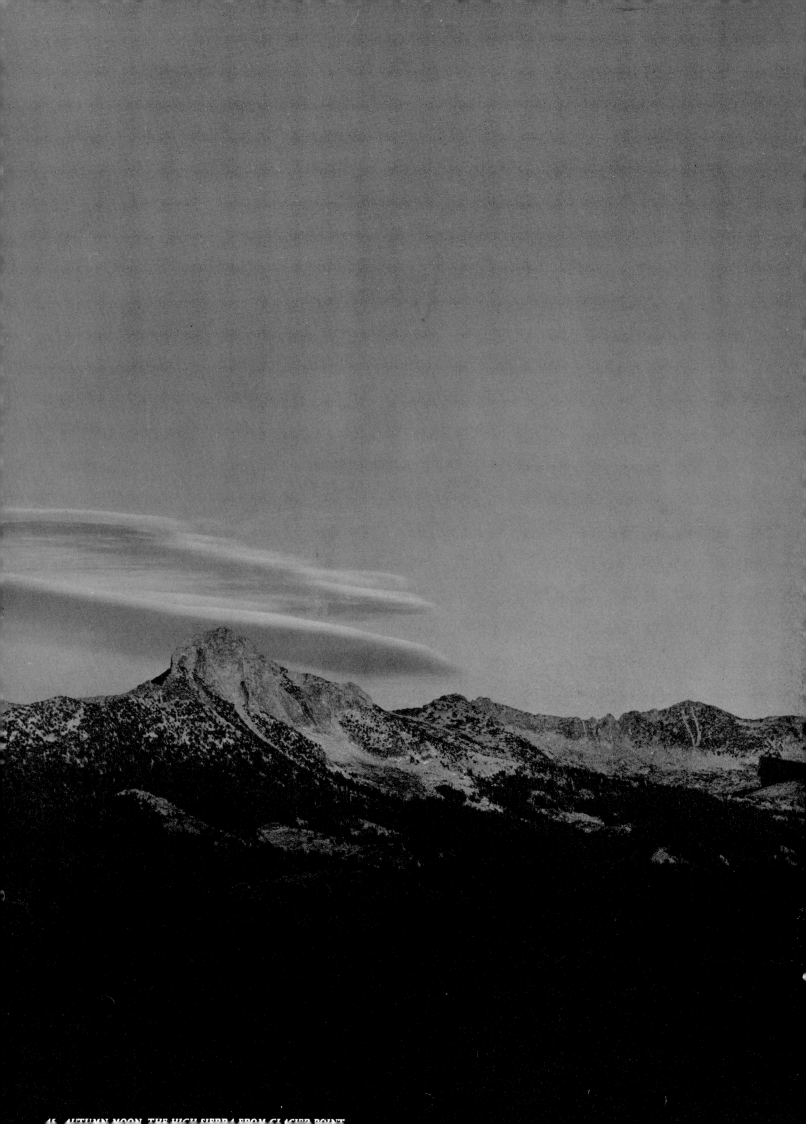

45. AUTUMN MOON, THE HIGH SIERRA FROM GLACIER POINT

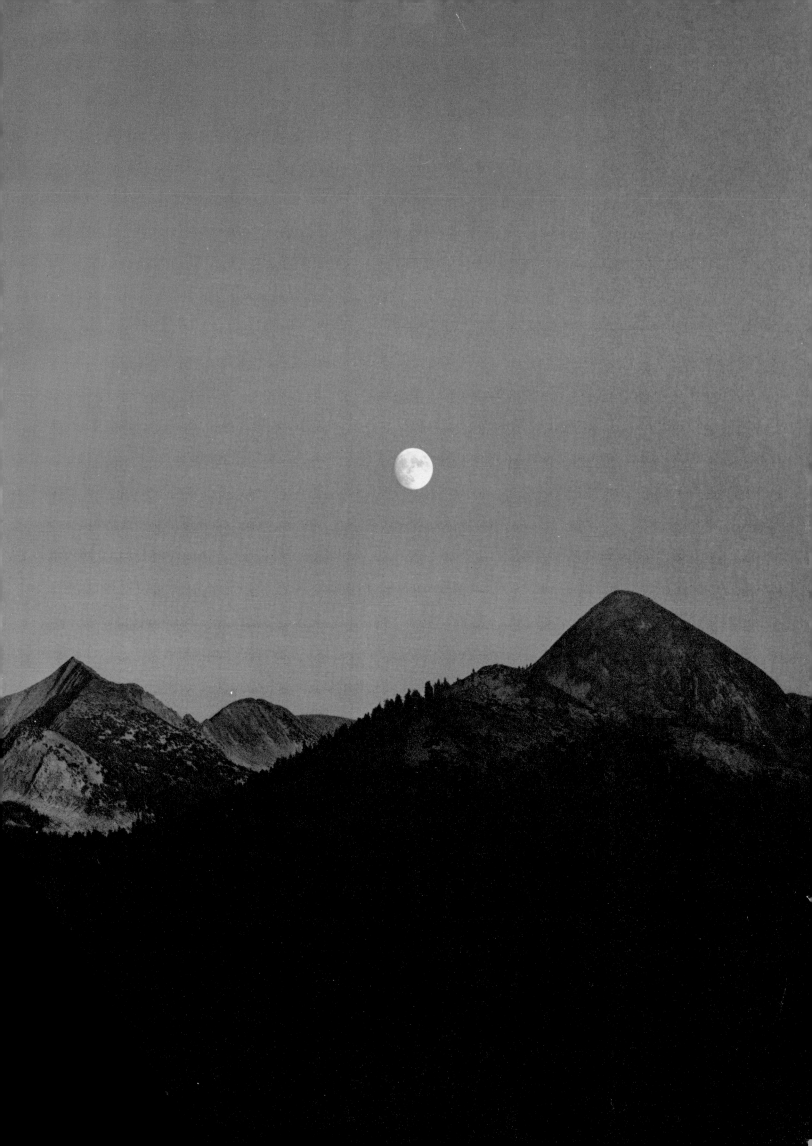

PHOTOGRAPHY IN YOSEMITE

In every season thousands come to Yosemite with their cameras, to record for themselves the majesty and beauty of the natural scene and their experiences with family and friends. Some may be advanced photographers but the majority are "snap-shooters." Tyros rush in where artists fear to tread but there is no reason why everyone should not achieve results appropriate to his interest and capacities. In this text will be found information and suggestions for both the amateur and advanced photographer. The aspects of Yosemite — the rocks, trees, waterfalls, the clouds and skies, and all the minutiae of nature — can be photographed and interpreted in many ways. Yosemite is not an easy place to photograph, especially in color. Problems of scale, contrast, etc., can be solved with some careful thinking and a common-sense approach. For the more serious photographers, there are specific texts listed in the Bibliography (page 64). All cameras can be used in Yosemite, but standard equipment may not always provide an adequate angle of view to include the lofty cliffs from points on the Valley floor. "Wide-field" lenses are helpful (for example, a 5″ lens with a 4 x 5 camera, or a 35mm. lens with a camera of 35 mm. format). Telephoto lenses are very useful when working from high points around the Valley, when composing details of the cliffs and waterfalls, or working with animals. Filters are generally required and the polarizer is helpful with both color and black-and-white films. Lens-shade, sturdy tripod when required, and other accessories should be considered, but first certain decisions should be made, such as — are we to work on the Valley floor, from or near the roads, which will make possible the use of heavy equipment, or are we to do a lot of trail hiking and climbing which necessitates light and portable equipment?

All equipment should be protected from dust and heat; cases should be painted white to reflect sunlight and keep the contents cool. Plastic bags are strongly advised for the protection of cameras, lenses, accessories and film from dust and moisture. Mist and spray from waterfalls and cascades should not be allowed to remain on lenses and — as there is probably some dust on the lens whenever the camera has been open for use — cleaning should be most carefully done with lens tissue. Do not fold up or replace a *wet* camera in its case — wipe off and dry as soon as possible after exposure to the elements.

Before you go into the mountains have your equipment carefully checked by a competent service man; especially the shutter (for actual speeds) and the bellows (for light leaks). Heartbreaking failures can be minimized by a thorough pre-check of equipment.

FILMS

For black-and-white photography the standard panchromatic films are, for most purposes, desirable. High-speed films are not needed except when working with people and animals under poor lighting conditions, with windblown flowers and rushing waters where short exposures are necessary, and when very small lens stops are required to achieve maximum depth of field with normal exposure times. Distant scenes are difficult with 35 mm. cameras, and fine-grain film is essential; sky and rock values seem to show negative grain more than deep shadows or highly textured objects. As there is very little red in the Yosemite scene, we can use orthochromatic film with excellent effect when we want light skies and enhanced atmospheric affects. We can achieve these effects on panchromatic film with moderate-strength blue or blue-green filters. For best results with average subjects, long-scale films are advised, as the contrasts of the Yosemite scene are usually rather high. Films such as Kodak Tri-X and Verichrome Pan, Ansco All-Weather Pan, and Ilford HP3 are excellent in this respect.

The most useful filters are: Wratten K1, K2, #12, (minus blue), G, A, C5 and X1, or equivalents in other makes.

For color photography most of the standard color films can be used with success: Kodachrome, Ektachrome, Anscochrome, Kodacolor, Ektacolor — all have their specific uses. The last two mentioned (color negative film) relate chiefly to the production of color prints and reproductions; the others yield positive images, and are fine for projection use, although they, too, can be used for prints and reproductions. New materials are constantly appearing and speed is being increased. Anything written here may be obsolete within a year — so the reader is advised to alert himself to current developments in this field. Color film — especially the positive type — has a much shorter exposure scale than does black-and-white film; we must select relatively "flat" subjects if we are to preserve integrity of color. In Yosemite, this means we must work mostly with backlighting to avoid burned-out high values and black, empty shadows. Color-negative material has a somewhat greater range, and errors in color balance can usually be adjusted in printing. The needed accessories for color photography in Yosemite include certain light-balancing filters and a polarizer. The latter is especially useful in reducing unwanted reflections and controlling the depth of sky values (when photographing at about 90° from the sun). In high altitudes the light tends to be more bluish than at sea level. Light-balancing filters (the Kodak 81 series and the Kodak skylight filter, or equivalents in other makes) "balance" the light to the standard color-temperature for which the film is designed. However, early or late in the day the light may be very warm and bluish filters are indicated (such as the Kodak 82 series).

Polaroid Land camera photography can be very rewarding, especially with the new Type 42 (Polapan, the 3¼ x 4¼ roll film), and Type 53 (Professional Pan Land 4 x 5 packet) which, with the appropriate adapter, can be used in any standard 4 x 5 camera. Polaroid Land film has a somewhat shorter exposure range than conventional film; the range of type 53 film approximates that of positive color film. We are obliged to avoid high-contrast subjects if we want the most pleasing results. The standard type 42 roll film (Polapan) and type 52 4 x 5 film have a somewhat longer scale and, as with all Polaroid Land films, give the photographer the opportunity to

perfect his image on the spot by varying his exposure and improving his composition (using the first exposure as a "trial" image). Standard color filters and the polarizer are useful as with conventional film.

OPTICAL PROBLEMS

The problem of *scale* is not merely one of image size, and it is impossible to achieve an impression of scale by direct comparison of the Yosemite features with recognized small objects. Scale is suggested in several ways: by an appropriate relationship of the dominant form to the picture space — by proper placement of a small-size form in a large space (such as a distant mountain rising with impressive simplicity under a vast sky)— by exaggeration of near-far relationships (rendering a small close object large against a small image of a distant object; this is possible with short-focus lenses with great depth-of-field). There is a "scale of space" as well as a "scale of size." The photographer should try to visualize his picture rather than just "observe" the scene before him.

Orientation of the camera is important. In many cases we are obliged to point the camera upwards to include the desired field of view. Meadow lines are horizontal, pine trees are usually vertical; pointing the camera up (or down) produces convergence of straight lines, and tipping the camera sidewise will tilt the meadow lines and the distant horizons. Convergence is acceptable and logical, but horizontal tilting can be disturbing. Hence, try to keep the camera level horizontally, and if the camera has view-camera adjustments (rising front, tilting-back, etc.) vertical image distortions can be corrected to a considerable extent. "Angle-shots" can be distressing if not properly composed.

Depth-of-field (relating to the acceptable sharpness of various planes of the subject) is a function of the focal-length of the lens, subject distance, and lens stop used. Unless we intentionally work for planes of varying clarity of focus we will find that lenses of shorter focal-length will serve our purpose best for average Yosemite scenes where both foreground and background are important. Depth-of-field tables are available for lenses of all focal-lengths, and are frequently engraved on the lens mount.

Motion of wind-blown branches and clouds is sometimes greater than anticipated and produces blur in the image — even at relatively short exposures. As for water movement, we can sometimes utilize image-blur to give the impression of rushing water. This applies to water close at hand — the greater the distance, the sharper the image should be. Complete arresting of water movement produces a glass-like effect which is seldom pleasant. The shutter speeds required for waterfalls vary as the distance dictates — Bridalveil Fall from the Tunnel Esplanade can be photographed at 1/5 second with a 5 to 7 inch lens; from the parking area near its base at 1/25 second; from the bridge on the footpath 1/50 - 1/100 second, and from near the base of the falls, 1/250 - 1/500 second. Vernal Fall from near Lady Franklin Rock will require at least 1/100-second exposure, chiefly because of the rushing river close by. Obviously the exposure appropriate for a small print might not be adequate when that same picture is considerably enlarged; motion might show in the latter

to a disturbing degree. This applies to 35-mm. color pictures as well, when projected on the screen; blur, due to motion will be much more apparent than when the slide is seen in a small viewer. Hence, it is a good rule of thumb to use shutter speeds of 1/100 second or less with reasonably near subjects including moving water when we are to make large prints or project color slides.

LIGHT AND COLOR

As we ascend to higher elevations the thinner air transmits more light from the sun, and the shadows are heavier because of the deeper blue of the sky. In general, the basic contrast of the scene increases with altitude. The light also becomes "bluer" and light-balancing filters are needed with color photography.

Snow, granite, bleached dead wood and sand reflect considerable light of "neutral" color value. Grass, poplars. oaks and conifers reflect greenish light of different values. Trunks of the valley pine trees reflect yellowish light. Autumn foliage reflects a good amount of yellow, orange and red light. If the shadows of our subjects are illuminated in part, or well supported by "colorful" reflections, the filter used must be selected with care; a green filter, for example, might overemphasize a shadow illuminated chiefly by reflected light from sunlit meadow grass, but might give perfect rendition of values illuminated from the sky alone.

In Yosemite Valley, even in open meadows, the shadows are not as blue as they would be in equally high but open country. The great height of the cliffs shuts out some light from the sky, and cliffs (when sunlit) reflect some neutral-colored light into the shadows. The dark pines and cedars reflect very little light, and in the groves they cut off light reflected from sky and cliffs. As the dominant light — both sun and shadow illumination — is largely *top* lighting, the contrast may be excessive at most times of the day.

As the color saturation of general subjects in Yosemite is quite low, filter effects are not as strong as in more colorful regions. A filter transmits its own color freely and shuts out other colors to a degree dependent on the type and power of the filter. With dilute colors the practical controls offered by the standard filters are surprisingly slight. Actually, for practical purposes, there is not much difference between the Wratten K1, K2, #12, and G filters when applied to the Yosemite scene, except that as the blue-light absorption increases, the sky and sky-illumined shadows will be rendered darker (and the atmospheric haze reduced). The red filters (Wratten 25A and 29F) will strongly affect the blue sky and shadows, rendering both very deep in tone, and increasing the general contrast of the scene. A red filter screens out green light, but foliage will not be rendered completely black because of the amount of reddish light reflected therefrom and because of the scintillations of light from glossy leaves and pine-needles. A meadow acquires a sharper textural effect when photographed with a red filter; the highlights from each blade of grass take precedence as the body of the green blade is lowered in value. Of course, shadows on and in the grass will appear quite dark.

There are few colors in nature which approach "high saturation" (in common terms, high brightness of color).

A very brilliant autumn leaf or a bright flower may have "high saturation of color" but most colors of rocks and foliage are of "low saturation"—that is to say, the colors are mixed with varying amounts of other colors of the spectrum. The lower the color saturation, the less effective color filters will be. For example, the sky at or near the horizon will be practically a neutral gray; in smoky areas it may be yellowish. The sky north of the zenith in high altitudes may be an extremely deep blue. In the first example a medium-yellow filter (such as a Wratten K2) would be ineffectual. It might show the sky *lighter* in the second example, and would render the sky much darker in the third example. Average foliage, especially the Sierra conifers, has a low saturation of green (and low brightness value as well) and color filters have little effect upon it.

A possible result of using an over-strong orange or red filter is an excessive darkening of the blue sky and the deepening of open shadow values — consequently producing a "lunar" effect in the image. This effect is somewhat at variance with the mood of bright, enveloping light so characteristic of the Sierra Nevada.

In Yosemite the dominant colors in spring and summer are grays, greens and blues — with an occasional bright flower, white cloud and snow bank, and the bluish-white of waterfalls and cascades. Only in autumn do we have strong colors of yellow and reddish hues. Hence, color photography can be very disappointing in Yosemite unless we take advantage of every possible display and situation of color — early and late light, rainbows and flowers — and use "skylight" and light-balancing filters to overcome the prevalent bluish cast of high-mountain landscape. Due to the position of Yosemite relative to the San Joaquin Valley to the west, later afternoon sunlight and sunsets are rather colorful since haze and smoke from the lowlands are carried toward the mountains by the prevailing winds. The cliffs will sometimes appear very yellowish for this reason, and the use of *bluish* light balancing filters (Kodak series 82 or equivalent) is indicated.

Where exaggerated planes are desired in a receding landscape (such as with a series of forested ridges seen in flat light) some emphasis of the atmospheric values will obtain when no filter is used. A maximum feeling of air and space is given by a blue filter, such as the Wratten #47 (C5), because the atmosphere is being recorded on the film with super-visual intensity. A blue filter will slightly reduce the brightness of white areas, such as bright clouds and snow, and of course, renders shadows illuminated by the open sky lighter than as perceived by the eye. The blue filter is a useful tool — it makes possible effects approximating those of the old "color-blind" plates.

SNOW PHOTOGRAPHY

In snow photography we know that medium-strength yellow filters such as (Wratten K1, K2, and #12) will strengthen the textural quality of snow (the minute shadows of the snow structure, being bluish, are deepened in tone). But when heavy filters are used (G, A, and F) the shadow values may be depressed to a degree where the snow loses its "snowiness" and appears harsh and granular (like coarse sand). In a snowscape the feeling is usually one of brilliance and a saturation of light; if the shadows

are too dark the entire character of the scene is changed—a "lunar" quality results and ordinary objects (much less bright than the snow) will be rendered much too dark.

FILTER EXPOSURE FACTORS

As we gain altitude and as the light becomes more bluish (higher color temperature) we must generally increase the published exposure factors for yellow, green and red filters, and decrease the factors for the blue filters. The following table suggests the best filters for various subject and lighting conditions:

SUBJECT	ORTHOCHROMATIC FILM	PANCHROMATIC FILM
Average Mountain Landscape	K2	None, K1, K2
Same, with intense shadows	K1, K2	None, K1
Same, with much conifer green	X1, B, K2	X1, B
Landscape in shade or overcast	K2, G, #12	K2 (increase factor)
Distant landscape	#12 or G	#12, G, A or F
Portrait in sun	K1, K2	None, or X1
Portrait in shade	K2, G, #12	X1 or K2 (increase factor)
Clouds and sky	K2, #12, G	K1 (with short exp.) K2, G (with reduced development)
Close detail	None	None
Contrast subjects, for full shadow detail	C5	C5
For exaggeration of atmospheric recession	C5	C5
Landscape into sun, with bright reflections or snow	None or C5	C5 or none
Late in day, for *Sunlit* values	K2	K1 or K2
Late in day, for *Shadow* values (which may be very blue)	C5	C5 (reduce factor)

Just how much to increase or reduce filter exposure factors is difficult to state with accuracy. In Yosemite Valley we might add 1/3 to 1/2 to the factors of the yellow, green and red filters, and subtract 1/3 from the blue filter factor.

The polarizer is invaluable for deepening the sky tones (maximum effect is obtained when axis of the polarizer is at 90° to the sun), and for clearing haze in distant landscapes. It is also useful in reducing unwanted reflections from water, glaring rock surfaces, etc., when the viewing angle is 54° from normal (36° from the surface photographed), and the polarizer rotated for the desired effect. It does not alter the relative color values of the subject. The basic exposure factor is about $2\frac{1}{2}$ X. Removing sparkling reflections from snow, water, etc., *may* destroy the illusion of both light and substance, but fortunately the effects may be observed visually — either by looking through the polarizer (and placing it on the lens at optimum position), or by examination of the ground glass image with the polarizer on the lens. The polarizer offers the only known way to achieve dark skies in color photography.

Filters for Color Photography

The following table will be helpful, but it is only approximate and based on average conditions. In winter the same filters will apply, but with one or two hours difference in the sunrise and sunset periods. In Yosemite Valley it is advisable to use the Kodak skylight filter (or the equivalent) at all times.

Summer	4000 to 6000 ft.	6000 to 8000 ft.	Above 8000 ft.
Sunrise to 8:30 a.m.....	No filter.........	No filter or No. 81.......	No. 81
8:30 to 10:40 a.m.....	No. 81	No. 81 or 81A............	No. 81A
10:30 a.m. to 2:30 p.m.	No. 81A........	No. 81A or 81B..........	No. 81B
2:30 p.m. to 5:00 p.m...	No. 81	No. 81 or 81A*...........	No. 81A*
5:00 p.m. to sunset....	No filter.........	No filter or No. 81*.......	No. 81*

*Omit if light is inclined to be slightly yellowish from haze or smoke. If the light is strongly yellow, use the bluish light balancing filters Nos. 82, 82A, 82B, or 82C.

EXPOSURE

Space does not permit a discussion of the principles of exposure (refer to several books listed in the Bibliography on page 64). The following table applies to films of ASA 64 (black-and-white) and ASA 10 (color) speed ratings, without filters. For films of ASA 125, give ½ the exposure value, and so on.

GENERAL VIEWS IN YOSEMITE VALLEY

SUBJECT	TIME OF DAY	BLACK AND WHITE ASA 64	COLOR (35 mm.) ASA 10
Flat light...............	9 a.m. to 4 p.m.	1/100 at f/16	1/25 at f/8-11
	Earlier or later*	1/50 at f/16	1/25 at f/5.6-8
Half shadow.............	9 a.m. to 4 p.m.	1/50 at f/16	1/25 at f/8
	Earlier or later	1/25 at f/16	1/25 at f/5.6
Heavy shadow...........	9 a.m. to 4 p.m.	1/25 at f/16	1/25 at f/5.6
	Earlier or later	1/25 at f/11	1/25 at f/4

GENERAL VIEWS FROM GLACIER POINT, ETC.

Flat light	9 a.m. to 4 p.m.	1/100 at f/16	1/50 at f/8
	Earlier or later	1/100 at f/11-16	1/50 at f/5.6-8
Half shadow.............	9 a.m. to 4 p.m.	1/100 at f/11-16	1/50 at f/5.6
	Earlier or later	1/100 at f/11	1/25 at f/8
Heavy shadow...........	9 a.m. to 4 p.m.	1/100 at f/8-11	1/25 at f/8
	Earlier or later	1/100 at f/5.6-8	1/25 at f/5.6

PEOPLE, ANIMALS ON FLOOR OF VALLEY

In sun.................	9 a.m. to 4 p.m.	1/100 at f/11	1/50 at f/5.6-8
	Earlier or later	1/100 at f/8	1/25 at f/5.6
In open shade..........	9 a.m. to 4 p.m.	1/25 at f/11	1/25 at f/4
	Earlier or later	1/25 at f/8	1/25 at f/2.8
In deep shade..........	9 a.m. to 4 p.m.	1/25 at f/5.6	Don't try
	Earlier or later	Don't try	Don't try

*"Earlier or later" signifies about 1 hour after sunrise and about 1 hour before sunset. In early Spring and late Fall, give about ½ stop larger than indicated above. In Winter, give about 1 stop larger than indicated above. *Except* when there is much snow give exposures as indicated. Remember to give increase of exposure for the appropriate filter used. Under similar lighting conditions Half Dome from the Valley floor might require a K-2 filter; from Glacier Point a No. 12 or a G filter.

The above exposure values are indicated for ordinary sunny days, with or without scattered clouds. For a hazy day, give one stop larger than indicated and for an overcast day (not just a local cloud-shadow) give two stops larger than indicated.

In the Mariposa Grove of Giant Sequoias give same exposure as for "People, animals, etc." *in deep shade.* Give the fastest exposure possible for moving water near at hand. If other than the listed stops are used, be sure to give the proportionally correct exposure.

MOTION PICTURE CAMERAS

Most 8-mm. and 16-mm. cine cameras operate at 1/30 or 1/40 second at normal speed setting (16 frames per second.) It is safe to assume that the 1/30-second speed is effectively equal to 1/25 second with the between-the-lens shutters on ordinary cameras. With the film-speeds listed by the manufacturers, it will be a simple matter to compute the required exposures from table. Be sure to "pan" slowly and to avoid subjects of excessive contrast.

SOME SUGGESTIONS

The camera does not "see" as does the eye, and if we understand this, and think about the way the camera interprets the scenes before us we will achieve more satisfactory results. The eye sees the world much as we *want* to see it; it can scan a wide field of view, or concentrate upon a distant object, at will. A distant mountain may appear majestic to the eye, but with a normal lens may turn out distressingly small and weak in the photograph. The eye can "see" a tree in the forest standing clearly among its fellows, but in a photograph it may be dissapointingly confused with its background.

The eye makes a rapid adjustment to varying brightnesses of the scene; we are aware of a soft and enveloping light in a forest scene — but a picture thereof might turn out as a harsh mixture of white and black areas. The film has a limited contrast range and unless we follow some special procedures we will not be able to re-create the mood of the scene — either in a transparency or a print.

The eye has a keen and consistent response to colors; it can perceive subtle differences of colors beyond the capacities of our films to record. As we know, black-and-white films record colors as varying shades of gray, and two different colors may — if their values (brightnesses) are the same, may appear as the same shade of gray. For example — a granite cliff under noon sunlight against the blue sky: with black-and-white film, even with moderate yellow filters, the values might appear the same in the picture. Again, a brown bear against a sun-flecked forest background is clearly perceived by the eye, but the film may "see" both as about the same value of gray. Color film would, of course, "separate" the colors somewhat as the eye would see them, but the image contrast would usually be greater than the scene contrast as seen by the eye. Such subjects would be photographically more satisfying under more positive lighting conditions; the cliff would be more effective under early or late sun, or against brilliant clouds, and the forest scene would be better if it was partially back-lighted. A Wratten #90 viewing filter is a most helpful device as it reduces all but the strongest colors of the scene to monochromatic values, and will thereby show where "mergers" and confusions of shape and texture of the subject may occur.

As we gain experience in photography we are able to "visualize" the final picture before we operate the camera. We can learn to anticipate certain effects — to know what the camera can, and cannot, achieve. It is important to keep notes; if a picture does not turn out as expected we will have some means of checking back and finding out the reason. Most photographers learn the hard way — by expensive and frustrating trial-and-error procedures. There is nothing mysterious about the photographic process! With a little thought and care surprisingly successful and consistent results will obtain.

EXPOSURE RECOMMENDATIONS

The orientation of Yosemite Valley (it lies in a generally east-west direction) provides a variety of light-and-shade effects which would be lacking if the Valley were lying in a north-south direction. There are definite times of day which reveal the rocks and falls of the Valley in the most favorable lighting aspects for conventional photography. While the advanced photographer delights in working with varied lighting conditions, it may not be denied that Vernal Fall, for example, exhibits its most interesting and vital water textures under mid-day sun. Earlier, the Fall is in complete shadow — later, it flattens out in the direct rays of the sun. El Capitan from the southeast is magnificent at sunrise, after which it flattens out, requiring clouds and cloud shadows for interesting form. In the late afternoon it assumes an exciting rim-light effect from this same viewpoint. As the seasons progress the angle of sun naturally varies and no exact advice is practicable.

The recommendations given below are for the simplest and most conventional aspects of the Yosemite scene under late spring and summer conditions. Whenever possible make a preliminary tour of the picture-taking locations so that you may more precisely define the proper time of day for your particular photographs. Actual exposure times depend upon the character and speed of the film used.

TIME OF DAY	FILTER	LENS

CASCADE FALL

10:00-11:00 a.m.	None, K1 or K2	Normal

From road near bridge, or from end of trail near Fall.

FROM WAWONA TUNNEL ESPLANADE

Early morning	K1, C5	Normal

For backlighted effects. (The C5 filter will enhance atmospheric effects.)

Mid-afternoon	K2, #12, G, X1	Normal

For maximum illumination; clouds and cloud-shadows helpful for maximum relief of form and space. The X1 filter will slightly lighten the greens of the forest. With the X1 filter the sky is rendered about the same as with the K2 filter.

Sunset	K2, G	Normal

Most effective with clouds. Lighting on the cliffs may be spotty. If general illumination is very warm, use very light filter and work for more-than-normal contrast by increased development of the negative.

Rainbows	K2, #12	Long-focus

About 3:00-3:30 the rainbow on Bridalveil Fall will be seen. It is not effective in black-and-white photography except with a rather long-focus lens.

	K2, G, #12	Normal

In late afternoon, if raining, rainbows may be seen arching the Valley. Work for considerable contrast, but do not use stronger filters. A K2 filter will reveal most of the rainbow, but too strong filters will shut out some of the color bands. But if the rainbow is weak, much contrast will be desired.

FROM VALLEY VIEW (On North Road)

Same as above	Same as above	Normal

Note that foreground river is in shade in late afternoon. Early morning effects are very fine, especially towards El Capitan and Ribbon Fall.

BRIDALVEIL FALL

11:00 to 1:00 a.m.	K1 or none	Normal or wide-angle

The best all-round lighting conditions are at this time of day. Before the sun strikes the Fall the mist clouds driving out from its base will be sunlit with spectacular effect. In mid-afternoon the Fall is flattened out in the direct rays of the sun. The rainbow appears in mid-afternoon from the Tunnel Esplanade, but much later in the day from the base of the Fall (between 5 and 6 p.m.). When working near the Fall watch for spray clouding the lens and wetting the camera.

EL CAPITAN

Sunrise to 10:00 a.m. and 3 p.m. to Sunset	K2	Normal or moderate wide-angle

From El Capitan view on the south road, and from the riverbanks from same general direction. Also good from road near base of Cathedral Rocks, and from Valley View. There is an excellent view (morning light preferred) from a point about 1.5 miles up the old Oak Flat road. This road is closed to automobiles but it is easy to walk to this location.

TIME OF DAY	FILTER	LENS

CATHEDRAL ROCKS

9:00 to 11:00 a.m.	K2	Normal

From east or northeast. In Spring there is a little pool, by the north road about one-half mile east of El Capitan bridge, which offers fine reflections of the Rocks.

2:00 to 4:00 p.m.	K1, K2, #12, G, C5	Normal

From any angle on the floor of the Valley, depending on the effect of sun and shadow desired. In late afternoon the west face of the cliffs will be in rather heavy shadow. The C5 filter will give exaggerated atmospheric effects.

4:00 to 6:00 p.m.	#12, G	Wide-angle

From El Capitan meadows in late afternoon, the oaks may be brilliantly illuminated by the sun against the shadowed cliffs. In Autumn the effect of brilliancy is augmented by the use of a strong yellow or orange filter.

CATHEDRAL SPIRES

Sunrise to 9:00 a.m.	K2, #12, G, C5	Normal or long-focus

It is difficult to find an unobstructed view of the Spires except from the environs of the road junction near the base of the Spires on the South Road. The Spires can be seen from the north side of the Valley, but from this distance they blend with the background cliffs. The C5 filter will exaggerate the atmospheric effects and create "relief" between the Spires and the background.

An exciting effect obtains in early morning when the foreground trees are in sunlight and strongly contrasting with the shadowed cliffs. The Spires themselves are edged with sunlight.

When the sun is slightly obscured by clouds the Spires can be photographed with the sun behind them; a very dramatic effect results.

In the late afternoon the entire subject is shadowed, except for touches of sunlight in the tops of the Spires.

THREE BROTHERS

Sunrise to 10:00 a.m.	K2, X1	Normal

Difficult to find unobstructed view. Best location is from the riverbank just below El Capitan. There is a good view from the South Road at El Capitan View.

Afternoon	None, K1	Normal or wide-angle

The highest of the Three Brothers (Eagle Peak) presents an impressive east face from the upper parts of the Valley, especially from the area near the Sentinel Bridge. It is most interesting when in near-full or full shadow, or when wreathed in storm clouds or mist.

SENTINEL ROCK AND SENTINEL FALLS

11:00 to 2:00	K1, none, C5	Normal or long-focus

The Falls are strikingly brilliant at this time, as the camera will be pointed towards the sun. The cliff of Sentinel Rock will be almost entirely in shadow, but presents a very decisive form. The best location is from the north directly across the Valley. Sentinel Rock and the Merced River can be photographed from the north side of the Valley opposite El Capitan View.

Late afternoon	K2, #12, G	Same

If too late in the afternoon the base of the Falls will be in shadow. Both the Rock and Falls will be in good illumination. Same location as above.

Sentinel Rock presents an interesting aspect from near the Old Village, especially in the afternoon, and dramatic views are to be had from the Four-mile Trail to Glacier Point.

YOSEMITE FALLS

Sunrise to 10:00 a.m.	K1, K2	Normal or wide-angle

The sun strikes the upper Fall around 8:00 to 9:00 a.m. (This varies with the season.) Before that time there is a beautiful quality of the Falls in full or near-full shadow. After 10:00 a.m. the Falls will be somewhat flattened out in the direct sun. A fine vantagepoint for the entire Falls is the spur road leading to the base of the Falls from near the Yosemite Falls Bridge. The Falls may be seen almost in entirety from the meadow west of the Old Village (on the south side of the Valley). A full view of all three sections of the Fall may be had from the Glacier Point Trail.

Afternoon	K1, K2	Normal or wide-angle

The Upper Fall is in sunlight considerably longer than the Lower Fall. The late afternoon effects on the upper Fall are spectacular, especially if the Fall is blowing in the wind, or if cloud shadows play across it and the adjacent cliffs of Yosemite Point.

GLACIER POINT

Early morning and late afternoon	K1, K2, C5	Normal or moderate wide-angle

Impressive from the north, either near The Ahwahnee entrance road or from (or near) the Stoneman and Ahwahnee bridges. There is an exciting view of the cliff buttresses from the Vernal Fall trail and Sierra Point (see below).

TIME OF DAY	FILTER	LENS

NORTH DOME, ROYAL ARCHES AND WASHINGTON COLUMN

Early morning and K2, #12, G Normal
late afternoon

Best general view from south—near Curry Orchard. Especially in late Spring when the Stoneman Meadow is lush with flowers and tall grasses.

Another fine view from the Happy Isles Bridge (the old bridge near the foot of Vernal Fall Trail).

The Royal Arches are overwhelming from several locations near their base. Proper lighting will reveal their powerful forms.

HALF DOME

10:00 to 11:00 a.m. K1, K2, C5 Normal or long-focus

Most of the impressive views of Half Dome are from the west. In the morning, most of the rock is in shadow and dramatic effects of light and shade are obtained with relative ease.

2:30 to sundown K2, #12, G Same

Maximum texture and form are revealed when the sun first strikes the great cliff of the Dome. Later in the day the effect is somewhat flatter, and clouds and cloud shadows are helpful. The sunset effects are exciting, especially with clouds.

MIRROR LAKE

Morning None, K1, C5 Normal or moderate
 wide-angle

Sun appears over Half Dome at various times, depending on season, and photographer's position on lake shore. Actual sunrise not photogenic but the quality of the reflections before the sun strikes the lake is usually very fine. From dawn to sunrise is undoubtedly the best time, as the reflections persist only a short time after sunrise. Before sunrise the contrasts are rather weak and the exposures should be carefully checked, as the light intensity increases sharply within an hour or less. A C5 filter will augment the impression of atmosphere and depth. A strong filter is not advised.

3:00 p.m. to sundown K2, #12, G Same

Late in the afternoon the foreground may be obscured in shadow. Clouds and cloud shadows are always helpful in this scene.

HALF DOME FROM SNOW CREEK TRAIL

2 p.m. to sundown **K2** Normal or wide-angle

One of the most impressive views in Yosemite. A wide-angle lens is required to encompass the whole mass of the Half Dome from the best viewpoint (about ⅓ or ⅔ up the trail to Snow Flat). The view up Tenaya Canyon is also very exciting, geologically and photographically.

SNOW CREEK FALL

Morning and afternoon K1, K2 Normal

A rather steep scramble to the best viewpoint. One of the most spectacular water displays in the Park. The trail to Snow Creek branches from the main Snow Flat trail a good mile above Mirror Lake.

HAPPY ISLES CASCADES

Morning None or K1 Normal

Backlighting is inevitable in views from the usual locations on the Happy Isles. With some rough scrambling along the south bank of the river some exciting cascade views can be made, looking east and northeast. But be extremely careful when climbing along the banks of the river; the rocks may be wet and very slippery, and a plunge into the rushing cascades would probably be fatal.

VIEWS FROM SIERRA POINT
Vernal and Nevada Falls

10:00 a.m. to noon K1, K2 Normal or long-focus
3:00-4:00 p.m.

In the afternoon this view will be rather flat unless there are spectacular cloud effects.

Illilouette Canyon and Fall

9:00 to 10:30 a.m. K1 or none Same

Always against sun; in early morning or late afternoon the Fall and canyon bottom will be in shade.

Yosemite Falls

2:30 to 3:30 p.m. K2, #12, G Same

Very flat in morning. Excellent in afternoon when great buttress of Glacier Point is in shade and the sunlight glistens on the waterfall.

ILLILOUETTE FALL FROM VERNAL FALL TRAIL

The most popular view. Fall is seen edgewise. Can be exciting picture if great walls of Panorama Point and Glacier Point are properly composed. In Spring and early Summer the cascades of Illilouette Creek are very impressive. There is a near view of Illilouette Fall from a point on the 11-mile trail to Glacier Point, west of the bridge over Illilouette Creek.

TIME OF DAY	FILTER	LENS

VERNAL FALL

Sunrise to about 10 a.m. None or K1 Normal

Early in the day the effects will be that of shadow and glittering water. Watch for excessive contrasts.

About 11 o'clock Same Same

Probably best time to photograph this Fall; form and texture revealed by acute angle of sun.

After 3:00 p.m. K1, K2 Same

Water will be flat. Short exposure times and less-than-normal exposure indicated to prevent loss of detail.

The best views are from Lady Franklin Rock (near base of the Mist Trail). Views from the Mist Trail are impressive, but the driving spray is troublesome.

The view from the Vernal Fall Bridge shows a magnificent section of the Merced River cascades (in both directions from the bridge). Tree shadows on the cascades are not easy to manage, and a soft negative is desirable.

NEVADA FALL

Practically same light- Same as for Normal
ing as for Vernal Fall, Vernal Fall
except that sun strikes
Nevada Fall a bit later.

Views are best from Diamond Cascade Bridge, from the open flat above (site of old Snow's Hotel), from the river banks just south of the flat, and from the base of the steep section of the old trail to the top of the fall. A fine view is also to be had from Clark's Point (on the main trail to the top of the Fall) and from this trail where it crosses the steep rock slopes southwest of the Fall. From this point (and from Clark's Point as well) magnificent views are also obtained of Mount Broderick, Liberty Cap, and the back of Half Dome. (Also exciting views to the west of the massive form of Glacier Point).

VIEWS FROM GLACIER POINT
(And other high points around the Valley Rim)

From sunrise to sunset K2, #12, G, A, Normal and long-focus
 Infra-Red, C5

The great distant views are so varied and so exciting under different lighting conditions that it is difficult to make any specific recommendations here. The entire day can be spent at any of the rim points; views to nearly all points of the compass (as well as down into the Valley itself), may be made at all times of the day. Very long-focus lenses reveal the splendors of the distant peaks of the High Sierra. Perhaps the least interesting time of day is between 11:00 a.m. and 2.30 p.m. when the shadows are minimized.

THE GIANT SEQUOIAS

Early morning, late None Normal and wide-angle
afternoon preferred

While not in the Valley proper, most visitors see the Giant Sequoias. Soft, hazy sunlight preferred. Negatives should be amply exposed and cautiously developed. The mood is one of soft environmental light.

PORTRAITS (in sun)

Early morning, None, K1, X1 Normal or
late afternoon. Long-focus

A low angle of sun is preferred; otherwise there will be distracting shadow effects, especially in the eye sockets, under the nose, etc. The ideal background is the sky, but pleasing "environmental" portraits may be made against rocks, stumps, or a forest background, or against scenic backgrounds. In the latter case, the distant subjects should be in clear focus; sharp focus is not so important when the subject is posed against simple massive forms.

PORTRAITS (in shade)

Any time of day None, K1, K2 Normal or long-focus

The subject should be placed so that it is illuminated with a somewhat front, or moderate side lighting from the sky. Quite often a subject in complete shade will be so illuminated by reflected light from a distant cliff that excellent modeling and relatively high brightness are obtained. In any event avoid definite "top" lighting, such as will be found in the midst of the forest. Placing the subject so that he faces an open glade or meadow will provide good front lighting. Exposures should be ample, with consideration for the deeper values of the subject; otherwise a harsh effect is certain to be produced. While the light is relatively weak, the subject-brightness scale is greater than one may anticipate. Also in low-value illumination, reciprocity departure further increases contrast. Portraits in shade are perhaps to be preferred to those in full sunlight except when the backgrounds are very simple and in good compositional relation to the subject. The spotty effects which derive from sunlight filtering through trees are to be avoided unless the photographer is versed in special processing techniques, or understands the use of supplementary flash illumination.

ANIMALS

In many ways animals should be photographed the same as people. In fact, a "portrait" of an animal involves its environment. Simplification is important; the use of very long-focus lenses (most satisfactory with the miniature camera) will produce intensely "isolated" images. In such cases the background will be so completely out-of-focus as to provide additional simplicity and impact. Flash fill-in can be used to good effect if it is not exaggerated. Be extremely cautious in photographing the bears—they are dangerous to feed and to approach closely.

INFORMATION ON YOSEMITE NATIONAL PARK

GENERAL INFORMATION on the geology, natural history, ecology and history of the region may be obtained through the museums and programs offered by the National Park Service.

IN YOSEMITE VALLEY:

Yosemite Visitor Center. Open all year.

Happy Isles Nature Center. Summer only. The Junior Rangers, ages 8 to 12, meet here on weekday mornings.

Nature walks, illustrated talks, campfire programs — Given daily in summer, and at certain centers throughout the year.

OUTSIDE THE VALLEY:

Small Museums at the Mariposa Grove of Giant Sequoias, Glacier Point, and Tuolumne Meadows, explain and illustrate special features of these areas.

CONSERVATION: At the Le Conte Memorial in Yosemite Valley the Sierra Club maintains a permanent exhibit (summer only) and provides information on hiking and mountaineering. Information on mountaineering and the high Sierra is also obtain-

able at the Parsons Memorial in Tuolumne Meadows, operated by the Sierra Club.

ADVICE ON ROADS, TRAILS, ETC.: Obtainable at the Visitor Center in Yosemite Village and at Ranger Stations throughout the Park.

REGULATIONS: For your protection, as well as the preservation of your Park and its wild inhabitants, please observe all regulations. They were made for your safety.

REMEMBER THE FOLLOWING SIMPLE RULES:

1. Do not molest or feed the deer, bear, or other animals.
2. Do not leave a fire unattended.
3. Do not explore or hike alone.
4. Stay on the trails.
5. Tell some responsible person where you are going.

If accidents or other emergencies do occur, report them immediately to a ranger, or telephone FRontier 2-4466.

A SELECTED BIBLIOGRAPHY

GENERAL AND DESCRIPTIVE

Adams, Ansel and Virginia
 Illustrated Guide to Yosemite Valley

Adams, Ansel and John Muir
 Yosemite and the Sierra Nevada

Butcher, Devereaux
 Exploring our National Parks and
 Monuments

Chase, J. Smeaton
 Yosemite Trails

Clark, Lewis W.
 Pocket Guides and Trail Guides to:
 High Sierra Camp Areas
 North Country of Yosemite
 South Boundary Country
 (all out of print)

Farquhar, Francis P.
 Place Names of the High Sierra
 Yosemite, the Big Trees, and the High
 Sierra, a selective bibliography

Huth, Hans
 Yosemite, the Story of an Idea

Le Conte, Joseph
 Ramblings Through the High Sierra

McDermand, Charles
 Yosemite and Kings Canyon Trout

Muench, Josef
 Along Yosemite Trails

Muir, John
 My First Summer in the Sierra
 The Mountains of California
 The Yosemite
 Studies in the Sierra

Shankland, Robert
 Steve Mather of the National Parks

Sierra Club
 A Climber's Guide to the High Sierra
 Going Light — with Backpack or Burro

Starr, Walter A., Jr.
 Guide to the John Muir Trail

Teale, Edwin Way
 Wilderness World of John Muir

Tilden, Freeman
 The National Parks: What They Mean to
 You and Me

Winkley, John
 John Muir, Naturalist

Wolfe, Linnie Marsh
 John of the Mountains
 Son of the Wilderness

HISTORY AND INDIANS

Barrett, S. A. and Gifford, E. W.
 Indian Life of the Yosemite Region (formerly called Miwok Material Culture)

Brewer, William H.
 Up and Down California

Bunnell, Lafayette H.
 Discovery of the Yosemite

Crampton, C. Gregory
 The Mariposa Indian War

Hubbard, Douglass
 Ghost Mines of Yosemite

Hubbard, Fran
 A Day with Tupi

Hutchings, James M.
 In the Heart of the Sierras

King, Clarence
 Mountaineering in the Sierra Nevada

Paden, Irene, and Schlichtmann, Margaret
 The Big Oak Flat Road

Russell, Carl P.
 100 Years in Yosemite

GEOLOGY, PLANTS, ANIMALS, BIRDS

Armstrong, Margaret
 Field Book of Western Wild Flowers

Grinnell, Joseph and Storer, Tracy
 Animal Life in the Yosemite

Hall, Harvey M. and Carlotta C.
 A Yosemite Flora

Hoffmann, Ralph
 Birds of the Pacific States

Hubbard, Fran
 Animal Friends of the Sierra

Jepson, Willis Linn
 Manual of the Flowering Plants of
 California

Matthes, François E.
 Geologic History of the Yosemite Valley
 Incomparable Valley

Murie, Olaus
 Field Guide to Animal Tracks

Peterson, Roger Tory
 Field Guide to Western Birds

Storer, Tracy and Tevis, Lloyd P., Jr.
 California Grizzly

Sumner, Lowell and Dixon, Joseph
 Birds and Mammals of the Sierra Nevada

Tresidder, Mary
 Trees of Yosemite

White, John R. and Fry, Walter
 Big Trees

NOTE: *See special issues of*
 Yosemite Nature Notes.

PUBLICATIONS

Sierra Club Bulletin (*annual and monthly*)
Yosemite Nature Notes (discontinued)
Auto Tour of Yosemite, *Ditton and McHenry*
Birds of Yosemite, *Stebbins*
Broad-leaved Trees of Yosemite, *Brockman*
Cone-bearing Trees of Yosemite, *Cole*
Devils Post Pile National Monument,
 Hartesveldt

Fishes of Yosemite, *Evans and Wallis*
Geology of Yosemite Valley, *Beatty*
Guide to Yosemite Sequoias, *McFarland*
Nature Trails — Self Guiding
 Inspiration Point, *Carpenter*
 (out of print)
 Mariposa Grove
Mammals, Yosemite, *Parker*
Mother Lode Country, Guide to, *Brockman*

Place Names of Yosemite Valley, *Hartesveldt*
 (out of print)
Reptiles and Amphibians, *Walker*
Yosemite Indians, *Godfrey*
Yosemite Waterfalls, *Menning*

PHOTOGRAPHY

Adams, Ansel
 Making a Photograph
 Michael and Anne in the Yosemite Valley
 Sierra Nevada, The John Muir Trail
 My Camera in Yosemite Valley
 My Camera in the National Parks
 Basic Photo Series:
 I Camera and Lens
 II The Negative
 III The Print
 IV Natural-Light Photography
 V Artificial-Light Photography
 Portfolio I
 Portfolio II (The National Parks and
 Monuments)
 Portfolio III (Yosemite Valley)

Newhall, Beaumont
 History of Photography

Newhall, Beaumont and Nancy
 Masters of Photography

Weston, Edward and Charis
 California and the West

MAPS

Yosemite Valley — U.S.G.S.
Yosemite National Park — U.S.G.S.